Renew by phone or online
0845 0020 777
www.bristol.gov.uk/libraries

Bristol Libraries

PLEASE RETURN BOOK BY LAST DATE STAMPED

BR100

ISSAL
23304 Print Services

John Golding

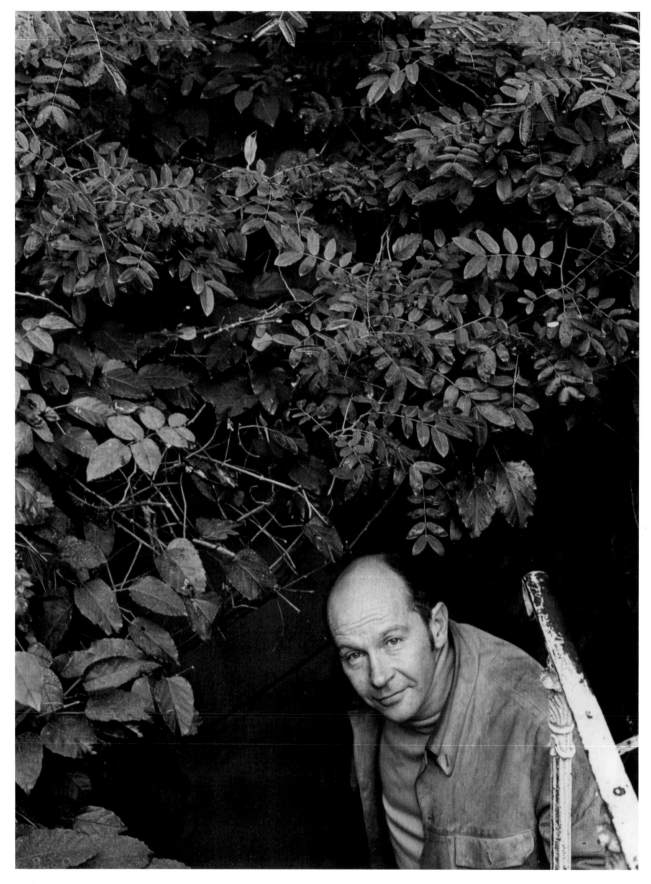

1976

JOHN GOLDING

Dawn Ades

David Anfam

Elizabeth Cowling

Christopher Green

Edited by Jenna Lundin Aral

Ridinghouse

This publication is made possible by a generous contribution from
PIANO NOBILE, London.

Contents

John Golding's Early Paintings and Modern Art in Mexico

Dawn Ades

While I was studying modern art in John Golding's small MA group at the Courtauld Institute, he was preparing his book on Duchamp's *The Bride Stripped Bare by Her Bachelors, Even*.[1] I did not appreciate then, in 1968, how far this, which remains one of the best accounts of that enigmatic work, took him from his core interests following his magisterial *Cubism: A History and an Analysis* (1959): namely non-objective art and the abstract sublime. He had interviewed Duchamp twice in New York, falling 'under his legendary spell'. Golding's teaching, as infectious as ever, featured Duchamp strongly, and undoubtedly influenced the first course I taught in the autumn of 1968 at Camberwell School of Art, a whole term on Duchamp. Early in October, Duchamp's death was announced and at the same time the existence of a hitherto unknown, major work, blowing apart the widely held belief, in line with radical attitudes of the 1960s, that Duchamp had given up making art since the 1920s. Golding had never been interested in Duchamp from that point of view and easily incorporated an epilogue on *Etant donnés* (1946–66) in his book. What Duchamp seemed to stand for then – 'an-art', as he put it, meaning 'no art at all, rather than anti-art, and an unrelenting conceptualism – was defied in Golding's book, but his own interests as a painter still seemed light years away from anything related to Duchamp. A small hard-edge abstract collage in his room at the Courtauld quietly established him among us students as a practising artist, and turned out to anticipate the solo exhibition of large, abstract acrylic paintings at the Museum of Modern Art, Oxford in 1971.

But Golding's origins as a painter lie in a quite different and unexpected direction, linked to his childhood and youth in Mexico, and only marginally connected to the European and American traditions of abstraction that he was to be so intimately engaged with. He was interested when I began to develop courses on Latin American Art at the University of Essex, around 1971; was a

generous source of information when I started travelling to Mexico and elsewhere in Latin America to collect material; and handed on books on the muralists with a rather detached air, which gave no inkling of his earlier attachment. He was still on close terms with many artists in Mexico such as Leonora Carrington and Gunther Gerzso, and not only told many anecdotes but gave introductions. Over the years we would discuss the muralists, on whose merits we had divergent views. His strong preference was for José Clemente Orozco, and he had little time for the political pretensions of David Alfaro Siqueiros, or for the vast visual social histories of Diego Rivera. I had no idea then that his appreciation of Orozco was a great deal more than the taste of an art historian. It also seemed perfectly explicable in the context of his interest in the Abstract Expressionists, as Jackson Pollock's paintings of the late 1930s were strongly influenced by the Mexican artist. But this was only the surface. John's enthusiasm for Orozco was in fact extremely personal and closely identified with his own formation as a painter.

His early paintings, etchings and charcoal drawings lie broadly within the dynamic but contested visual traditions in a Mexico dominated by the muralists. As he later said in conversation with Richard Wollheim, 'My first experience of contemporary art was of the Mexican Mural Movement.'² A few early oils, such as *Masks* of 1950, are related to the brighter, modernist-inflected art of independent Mexican painters such as Agustín Lazo or María Izquierdo, and he was not immune to the pervasive indigenism, with etchings of peasant mother and child, market scenes and a fiesta [Fig.1], but the strongest influence was that

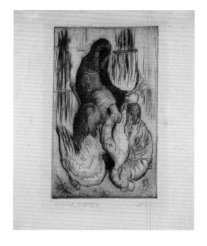

Fig.1
Market with Doves, 1954
Etching
21 × 16 cm
John Golding Artistic Trust

of Orozco. Orozco was in a sense the odd one out of *los tres grandes*, the three dominant figures among the mural painters, Rivera, Siqueiros and Orozco. Like them, Orozco was drawn as a young artist into the ambitious mural programmes set up by the new post-Revolution government. But he distrusted ideologies, disliked indigenism and held firmly to a belief in the necessary autonomy of art. His painting has been described as 'expressionistic modernism',[3] and he had a special liking for Cézanne and above all for El Greco, which coincided with Golding's interests. Looking at Golding's early paintings, from 1958–59, both subject and the manner of painting are close to Orozco. This is especially true of one of his main subjects: animals, often dead or dying, and human skeletons. A striking feature is the thick white lines of paint that give structure without being either contour or surface. This characteristic paint stroke is perfectly adapted to the skeletal bodies or skeletons, which often fill the entire picture, against a dark ground. Orozco often included skeletons in his murals, as in the savage satire *Gods of the Modern World* (1932–34) from the cycle at Dartmouth College, New Hampshire, or in some of the later oil paintings such as *Demagogue* (1946). But it was the less literal 'skeletal' effects in Orozco's figures, often painted in exaggerated, sinewy streaks, the bodies sometimes emaciated to skeletal carcasses, that struck Golding.

> Orozco was my greatest source of inspiration, and I still believe he is one of the giants of the twentieth century, although his output was so incredibly uneven. One of the features of Orozco's art is the way in which his figures all seem to be in some way flayed, they wear their skeletons on the outside, like armour, although it is an armour that is useless, and he mostly seems to see humanity as doomed.[4]

Perhaps it was a sense of the death in life or life in death of such images that prompted Golding to dedicate an oil of 1959 to him: *'Ananias' (Homenaje a Orozco)*. [Fig.22] The bandaged head might recall Lazarus rather than Ananias, but the figure is powerfully and freely conjured, in monochrome black and white against a fiery orange, which outlines his limbs as though they were aflame. Golding knew the frescoes Orozco painted at the Hospicio Cabañas in Guadalajara, whose centrepiece up in the dome is *The Man of Fire* (1938–39). There are also, undeniably, elements in *Ananias*, such as the teeth just visible in

the dark mouth, that resemble Francis Bacon's paintings of the late 1940s and early 50s, which Golding could have seen in London or New York.

With his abstract paintings, whether hard-edge or the later wonderful lyrical explosions of colour, Golding was to escape so completely from his early influences that it comes as a surprise to see the dark, figurative paintings such as *Esquelito* (1958) inspired by Orozco. [Fig.2] Golding felt, with considerable justification, that Orozco was the only muralist to care passionately about painting in itself and not as a route to something else, a tool for social or political ends. 'Painting in its higher forms', Orozco wrote, 'has invariable universal traditions from which no one can separate himself'.[5]

Another of Golding's main themes at this time was the nude, usually male body, sometimes just the torso, as in the tender study *Desnudo Gris* of 1959 (p.37). *Standing Nude*, also of 1959 (p.39), is in more naturalistic colours, with a flesh-like pink torso against a green and blue ground, but in other respects has taken the dynamic thrust of Orozco's strokes towards abstraction, as though the body dissolves in the paint. Like a void in the centre is a patch of black where the face would have been.

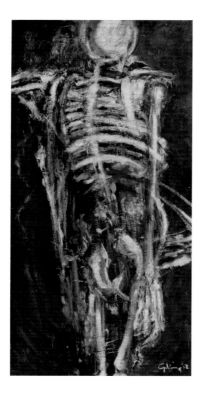

Fig.2
Esquelito, 1958
Oil on board
127 × 66 cm
Private Collection

It is strange to realise that these and *Ananias* were painted the same year that *Cubism* was published; also in 1959 he visited Orvieto in Umbria and painted a number of figure scenes, many based on the Signorelli *Resurrection of the Flesh* (c.1499–1502). Where Signorelli's naked bodies are drained of colour, Golding restores a flesh pink. [Fig.3] Perhaps one of the reasons for his fascination with this fresco was the procession of skeletons advancing to receive their flesh again, which must have reminded him of the tradition of the *calavera*, living skeletons, in Mexico.

Apart from the sketches in Orvieto, which were dated, it is extremely hard to date Golding's work over the next few years. Nonetheless, up to the next firmly dated group of works, the extraordinary collages of 1964, the seeds of his later abstract paintings, and their relationship to the body, are sown. He was leading a kind of double life. While his career as an art historian was burgeoning, he was also enjoying recognition as a young painter in Mexico, where he returned for some time around 1959 to 1960. The Galería Diana on the Paseo de la Reforma, Mexico City, held a one-man show in November 1958, at which he showed 12 oils, including the Orozco-influenced paintings: the *Dead Horse*, *Skeleton* and the paintings of doves. In March 1961 he had another solo show of oils, now at the Galería Antonio Souza, where his close friend, the Mexican artist Gunther Gerzso, also exhibited. This gallery then organised a remarkable exhibition *Pintura Mexicana Contemporanea* (Contemporary Mexican Painting), which took place from April to May 1961 at the Institute of Contemporary Art in Lima, Peru, and seems to have completely escaped the

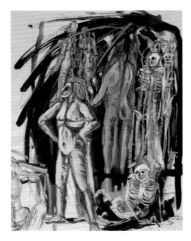

Fig.3
Orvieto, 1959
Ink and gouache on paper
53 × 40.5 cm
John Golding Artistic Trust

attention of art historians. The roster of artists exhibiting is extremely impressive, ranging from established artists like Rufino Tamayo and the relatively well-known Surrealists Leonora Carrington, Remedios Varo, Wolfgang Paalen and Alice Rahon, to young Mexican artists, still relatively unknown, such as Francisco Toledo. [Fig.4] Toledo showed *Rain Man* (c.1960s) and a number of watercolours; this must have been his first exhibition outside Mexico but it doesn't feature in his exhibition records. Mathias Goeritz showed his gold leaf paintings. Goeritz, like Carrington, Varo, Paalen and Rahon, was a refugee from Europe and in this cosmopolitan company Golding is on the one hand perfectly at home, but is also, paradoxically, more distinctly aligned as an artist with the Mexicans. Unfortunately, there are no titles for Golding's works in the exhibition, which are listed simply as 'gouaches and engravings', but these are almost certainly related to the dark skeletal paintings, and probably included the Orozco-inspired etching of a male nude, with skeletal ribcage. [Fig.5]

Charcoal drawings, black ink washes and gouaches bear witness to an intense period of scrutiny and experiment over the next few years. Bodies, sometimes single, sometimes a pair, both male and female, usually headless,

Fig.4
Leaflet for the 1961 exhibition *Pintura Mexicana Contemporanea de la Galería de Antonio Souza* at the Instituto de Arte Contemporaneo in Lima, Peru.

sometimes with a black hole instead of a stomach, undergo mutations and over-drawing. 'I realised that in my work I was somewhat desperately trying to find a compromise between a male and a female body.'[6] A series of large, fine line drawings of a male torso on tracing paper are sometimes almost totally obscured with thick black hatchings. [Fig.6] The impulse to abstraction is strong, but the body wrapped in a dense mass of lines or streaks is often still visible. At the risk of being too literal, these powerful studies seem to bear out what otherwise I have found baffling in Golding's account of his move to abstraction, that 'the body is always there in my work'. They could be seen as the initial moves as he 'moved up into the centralised images of my earlier work. In the process the centralised images were abstracted, and the centralised image became the canvas in its entirety. The pictures themselves […] became metaphors for bodies.'

A correspondence during the early 1960s with Gerzso, to whom Golding seems to have spoken most freely about his own work, is revealing.[7] A letter from June 1963 is evidently in response to one from Golding expressing anxiety about his painting and missing their talks. 'I'm sorry that your painting is giving you trouble', Gerzso wrote. He is surprised that Golding has not found someone in London with whom to exchange ideas. Gerzso recognises that the problem, as Golding experiences it, is that he was becoming more and more successful as an art historian and lecturer, and therefore his life as a painter seemed less exciting. 'The combination painter-art historian is a particularly tough one, I think. In the long run one of the two will suffer.' Golding appears to have been

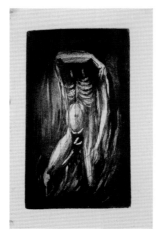
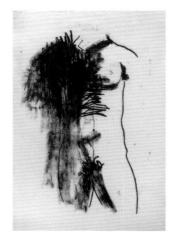

Fig.5
Standing Nude, c.1959
Etching
32.5 × 24.5 cm
John Golding Artistic Trust

Fig.6
Male Nude, c.1960
Charcoal on paper
64.5 × 44.5 cm
John Golding Artistic Trust

determined to prove Gerzso wrong. His upward trajectory as an art historian continued, and he was still writing brilliantly even after retiring both from his position as a lecturer at the Courtauld in 1981 and later from his subsequent post as Senior Tutor in the Painting School at the Royal College of Art. But painting, as both Gerzso and Golding knew, is a consuming business, if 'not worth getting physically ill about', as Gerzso reassured him, having received a letter 'full of gloom and despair'. Writing in December 1963, Gerzso says that he doesn't know how Golding is painting now, 'but your dark and tragic figures, surrounded by more blackness, are probably hard to force all of the time. It is like shouting the same despair over and over again. I cannot suggest to you what you should do about it.' A pressing question was how, if one wished to, one might change. 'I know from my own painting', Gerzso wrote, 'how hard it is to take up a different road. I always have the best intentions of changing – but in the end the emotional content is always the same, more or less.' Changes, if one is to remain true to oneself, cannot be willed. Returning to this problem a few months later he advised Golding:

> Don't be appalled by the violence and blackness of your painting. I repeat what I wrote to you many times before: try to go to the bottom of your violence and blackness, whatever the cost. I know this is not an easy thing to do because it is quite a lonely road. But don't fool yourself by thinking that all of a sudden you can decide to paint 'calmer and more hopeful' pictures. You won't succeed unless you deliberately go against yourself. What matters is that through painting we are able to receive flashes of insight which enable us to recognise the true nature of our emotions. This contributes more than anything else towards making a painting good or bad, I think. Unfortunately we seldom act according to these insights. We don't stop to think: how can we find out more about this 'thing' which is so powerful, and which dominates us so unmercifully. Many painters try to escape all this by imitating current fashions in art… etc., etc. So: try to be as black and violent as you can.[8]

From around 1960 there is a change in Golding's paintings, reflecting the exploratory drawings and gouaches. While still predominantly dark, the relationship between figure and ground shifts, or perhaps it would be better to

say the figure itself has become more abstract, more interconnected with the picture surface. Two very interesting paintings of 1961, *Cliff Dwellers* and *Figures in a Landscape*, have overall brown, black and deep red hues (pp.43, 45). Both seem to have been inspired by Native American or pre-Columbian culture, habitations and landscape, and, together with the flatter planes that entered his paintings at about this time, resonate with the paintings of Gerzso. These, in the early 1960s, are constructed of overlapping colour planes which appear to advance and recede, often against blackness, as in *Ritual Space* (1963). Although apparently abstract, a resemblance to old stone walls in a landscape is sometimes confirmed by Gerzso's titles, as in *Green Wall (Yucatan Landscape)* (1961). In calling his painting *Cliff Dwellers*, and depicting a feathered shape which could be a body or headdress, Golding may be referring more to the Native American pueblos of the south-east, at places like Mesa Verde in Colorado, where the ancient houses are built into and under the overhanging cliffs. A mysterious black structure with a small rectangular hole seems to be obscuring something coloured and perhaps feathered, while a long slab of dark purple blocks the right-hand edge of the picture. Whether the black rectangle has architectural connotations or whether it is a kind of figure/mask remains ambiguous when it reappears in *Figures in a Landscape*. Here it is repeated as if we are seeing both its front and its back, the two separated by a glowing ladder-like shape. These hover on a coppery, painterly ground that looks like hot metal. Several luminous green streaks running vertically down the left-hand side of the painting are extraordinarily prescient of the high colour and freedom of the painterly marks in Golding's later paintings.

There is a very strong sense of a presence, or presences, in *Figures in a Landscape*, as there is in Gerzso's paintings such as *Ancient Structures* (1955) or *Two Personages* (1956). In Gerzso's case this has been associated with the way that the indigenous past is experienced as an ever-living threat for modern Mexicans. Some artists and writers subdue and romanticise it, but others evoke phantoms that are 'real, at least for us [...] these ghosts are the vestiges of past realities'.[9] In his novel, *La región más transparente* (Where the Air Is Clear, 1958), Carlos Fuentes imagined Ixca Cienfuegos and Teodula Moctezuma prowling about 'in hopes of invading the "most transparent" region of the modern metropolis in order to resuscitate old rites and pre-Columbian powers'.[10] It is not too far-fetched to see Golding's 1960 painting *Le Transparent* in the light of Fuentes's evocation of this

past and its colonial horrors, only partially buried in the attempts to modernise Mexico. The central black shape in *Le Transparent* is featureless and in a sense formless, hinting at a face, a headdress, a mask, carried atop a staff like a trophy or an offering in a ritual. [Fig.7]

There is a more evidently geometric order in Gerzso's paintings than in Golding's, but he was not a constructivist in the mode of César Paternosto or Anni Albers, who based their abstract art on pre-Columbian textiles, architecture and mathematics. 'Gerzso created a style of painting that suggested tension without resolution'. Evading neither the past nor the present, he 'offered his viewers and critics a precise dose of this space of horror, straining it through the cracks of his paintings. His effectiveness in communicating emotion depends, in part, on the ambiguity with which his supposedly abstract painting [...] prompts a series of imaginary excursions through indigenous America'.[11]

But this conflicted relationship with modernity was not Golding's concern, in the end, and he probably wouldn't have agreed with this account of Gerzso's painting. The violence and blackness he talked of to Gerzso were probably, to begin with, descriptive of the grim paintings of dead animals and skeletons in

Fig.7
Le Transparent, 1960
Oil on board
148.6 × 109 cm
John Golding Artistic Trust

an Orozco-related style, and then carried into the dark, haunted image of *Le Transparent*; but the gloomy feelings he expressed are, in a more general sense, to do with his relationship to painting as a whole. The painting tradition he was now familiar with was that of Cézanne, Braque, Matisse and into abstraction, a tradition that had become purged of debts to God or society and was untrammelled by the historical guilt that many modernists in Latin America felt. But finding his way was still a lonely business and the dark drawings and paintings indicate an intense struggle of a personal nature. He was not, though, 'interested in art as self-discovery or as therapy'.[12] The first good abstract art he saw, he told Wollheim, was in New York in the late 1940s, and he responded to it immediately, though it took over a decade for him to find his own voice.

Golding's change to a hard-edge abstraction seems very abrupt. It appears as a determined move to escape the expressionism of the earlier paintings, by limiting himself to cut and pasted, minimal and elegant colour shapes. There is, however, a group of collages of 1964 – firmly signed and dated but never, so far as I know, exhibited publicly – which mark the break with painting in a very unusual way. [Fig.8] The cut-out fragments never touch each other, there are no surprising juxtapositions, nor is there a cubist-related interest in collage representing some real object within the picture. The fragments are sliced from his own engravings, and also from what look like experiments in decalcomania. This was a technique favoured by the Surrealists, in which a layer of gouache is laid on paper, another sheet is placed on top and peeled off, automatically creating the resulting image of forms, often resembling landscapes or caverns.

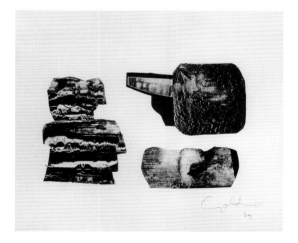

Fig.8
Untitled, 1964
Collage on paper
32 × 38.4 cm
John Golding Artistic Trust

The Surrealists encouraged a reading of these forms, but Golding, who was never drawn to Surrealism, seems to have used them purely for their abstract potential. However, the cut shapes usually still have a strong resemblance to a body or body parts. Some forms are even placed on a plinth giving them sculptural connotations. The collage elements float like archaeological specimens in a tray, and moreover the white space round them becomes as important pictorially as the image-fragments themselves. The white is frame, surface and ground, rather than a void, and anticipates the abstract papiers collés and collages that follow. In these, there is an oscillation between an emphasis on a figure–ground reversal, and a more ambiguous overlapping of planes. It is possible that Gerzso's paintings provided a hint towards Golding's hard-edge abstract paintings, and that the sense of planes and surfaces shielding and obscuring something behind them is still present in the huge geometric acrylics shown at the Museum of Modern Art, Oxford, in 1971. It is difficult, however, not to see the hard-edge abstract collages and paintings as an interlude, before Golding moved to a freer style, with paintings that are 'liberating and exhilarating', filled with space and light, and perhaps a resolution of the earlier dark paintings but not entirely denying them.

1 John Golding, *Duchamp: The Bride Stripped Bare by Her Bachelors, Even* (Art in Context), Allen Lane, London, 1973.
2 John Golding, 'From Mexico to Venice. Postscript: Interview with Richard Wollheim', *Visions of the Modern*, Thames & Hudson, London, 1994, p.338.
3 Laurance P Hurlburt, 'Notes on Orzoco's North American murals: 1930–34', in David Elliott (ed), *¡Orozco 1883–1949!*, exhibition catalogue, Museum of Modern Art, Oxford, 1980.
4 Golding, *Visions of the Modern*, op.cit., p.338.
5 José Clemente Orozco, 'Notes on the Early Frescoes at the National Preparatory School' (1923), in *¡Orozco! 1883–1949*, op.cit., p.34.
6 Golding, *Visions of the Modern*, op.cit., p.337.
7 Only one side of this correspondence seems to have survived. I am most grateful to Golding's nephew Michael Johnson for giving me access and permission to publish from it.
8 Letter from Gerzso to Golding, 10 July 1964.
9 Octavio Paz, *El laberinto de la soledad* (The Labyrinth of Solitude), Cuadernos Americanos, Mexico, 1950, p.79.
10 Cuauhtémoc Medina, 'Gerzso and the Indo-American Gothic: From Eccentric Surrealism to Parallel Modernism', in Diana C Dupont, *Risking the Abstract: Mexican Modernism and the Art of Gunther Gerzso*, exhibition catalogue, Santa Barbara Museum of Art, 2003.
11 *Ibid.*, p.213.
12 Golding, *Visions of the Modern*, op.cit., p.337.

1976

John Golding interviewed by Elizabeth Cowling

In March and April 1995, I interviewed John Golding for the Artists' Lives collection of National Life Stories, an oral history resource of the British Library and Tate Archive. The interviews, which were supposed to cover all periods and aspects of his life, took place in Golding's house in west London, and it was he who decided when we should stop on each occasion and that the fourth should be the last. He had agreed to be interviewed, he said, mainly because he had known many influential figures in the art world and had been involved in one capacity or another with a succession of major art institutions: he felt he could contribute usefully to the historical record. The following text consists of extracts from the interviews in which Golding spoke in most detail about his evolution, methods and motivation as a painter. But self-analysis in a public forum went against the grain of this innately private man and discussion of his own work tended to morph into commentary on the work of other painters.

The personal context for the interviews deserves mention. James Joll, his partner of almost forty years, had died less than a year before they took place, and although Golding did not speak about his profound sense of loss, his preoccupation with mortality emerges in various ways. Thus he was in the mood to reminisce and enjoyed speaking expansively about his childhood and youth in Mexico, his awakening artistic ambitions, discovery of the Mexican muralists and adoption by the Surrealists in exile, and then the thrilling revelation of European modernism and Abstract Expressionism during visits to New York while studying for his BA in art and archaeology at the University of Toronto. Conscious, moreover, that everything he said might be taken as his last word on the subject, he strove to be objective and fair-minded – even to err on the side of generosity – when assessing friends and colleagues. But Golding's underlying depression can be sensed in the anxiety he expressed about the

pitfalls of pure abstraction, to which he was himself irrevocably committed as a painter. In contrast to his parallel careers as an art historian and curator of exhibitions, his activity in his studio was in decline by the mid-1990s. In this regard, there is a striking difference from the confident tone of his fascinating 'dialogue' with Richard Wollheim, published in 1989 at a happier period of Golding's life, when he was highly productive as an artist and enjoying esteem and success.

He did not take up the offer to go through the recordings in order to revise or clarify anything he had said, contenting himself merely with ensuring that proper names in the eventual verbatim typescript were correct.

———

John Golding When I left school [Ridley College, St. Catharines, Ontario], I wanted to go to art school but, having won the scholarship [to the University of Toronto], my parents said, 'Why don't you take the scholarship and then, after that, do whatever you like.'

Elizabeth Cowling And you were painting all the time you were at university?

JG A little bit – on holidays and so forth, but really marking time, wanting to get on.

EC You had decided you wanted to be a painter?

JG Yes, definitely. But I wanted to go to Europe and the only way of getting to Europe was to come to the Courtauld [Institute]. And then I just got sidetracked until, eventually, I'd finished my PhD [in 1957]. The Courtauld offered me a job there but I turned it down and began painting – so, late in life, in fact. I decided I wanted to paint and I went to Italy and lived there off and on for the better part of a year.

EC Where were you, in Italy?

JG It was a very remote place on the coast outside Amalfi. For the first time I was painting full-time.

EC *What was your work like at that stage?*

JG It was still figurative and it was very much influenced by Orozco. I used to go, when I could, to Orvieto and I did a whole series of drawings from Signorelli. [Fig.3] But I was self-taught, really, as a painter. I would have liked to have stayed in Italy because I'd fallen in love with the country.

EC *Were all your Italian paintings figurative?*

JG Yes. I was fascinated by the spectacle of the farmers driving the sheep into the sea and washing them. I did a whole series from that.

EC *Back in London, in your studio in Battersea in the early 1960s, what was your work like at that point? When did it start to go abstract?*

JG Just then. After I'd done the Amalfi paintings, I moved into a very black phase of painting and the figures became increasingly abstracted, and then, eventually, I just moved into abstraction. It happened gradually. There's a sense in which I just moved up into what was happening in the pictures, and then they became abstract. It was an exciting moment for me.

There are so many ways of getting into abstraction, aren't there? One way is simply to move up and up and up into your image, so that the canvas itself becomes the image. Does that make any sense?

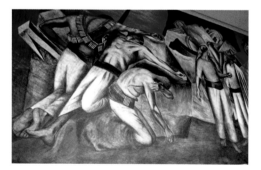

Fig.9
José Clemente Orozco
The Trench, 1926
Mural
Escuela Nacional Preparatoria,
Colegio de San Ildefonso, Mexico City

EC It does. But I have to say that I would never have thought of your abstract paintings in terms of the body.

JG No, nobody does, and everybody sees them in terms of landscape. But that doesn't bother me at all. It seems to me that paintings are just paintings; they have their own existence – and if they suggest landscape to certain people it doesn't worry me. And, of course, the format I use is a landscape format.

What is certainly true is that I see virtually everything I paint as being a homage to Cézanne now, and although I have my debts to countless artists he is certainly the artist with whom I continue to be most obsessed. I love it all, but it's his landscapes that feed my own painting. [Fig.10] Yet I continue to see my abstracts as really relating to body imagery.

EC In your interview with Richard Wollheim you talked about the 'veiling' of imagery in Kandinsky's kind of abstraction. Does it ever happen in your abstract paintings that there is something remotely figurative that is, as it were, veiled?

JG No. When I had the exhibition at the Mellon Center at Yale [1989], one of the critics talked about my abstraction as being 'veiled' because there is that sort of diaphanous quality to a lot of the paintings and a feeling of transparency. But to me that is totally pictorial. I don't see it as a psychological veiling at all.

EC When you talk about 'moving into the image' or 'moving into the body', is it always the human body?

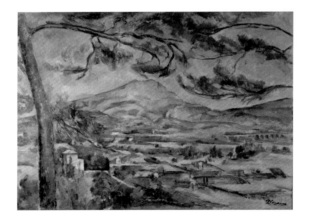

Fig.10
Paul Cézanne
Montagne Sainte-Victoire with
Large Pine, c.1887
Oil on canvas
67 × 92 cm
The Samuel Courtauld Trust,
The Courtauld Gallery, London

JG Yes. Invariably.

EC *And is it visceral? Emotional? Psychological? What is the relationship to the body?*

JG It's physical and certainly emotional – but it's now at such a distance because I have been working as an abstract painter for so long. I begin the pictures first of all just by staining the canvas, but then I put in an armature – a linear armature, which I still see as relating to those figures of Orozco's where there are bones on the outside, at it were. And I still see that armature as human, at a great distance. It relates to human anatomy and to the human condition in an odd way.

Subsequently, the picture takes over and it's just a question of painting. I lose the armature during the process of painting, and then I reaffirm it, and then I lose it again, then reaffirm it. A picture really begins to work for me when the armature is still there at some level – structuring the painting – but when it has entered into a sort of total dialogue and total fusion with the actual free use of paint. It's a question of coming and going, and when, eventually, the two aspects coalesce that's when I begin to see the picture as nearing completion.

EC *Does this have anything at all to do with Cubism?*

JG To the extent that I'm very aware of and have been very influenced by Braque, and fascinated by the way in which Braque folds space. He can take the space of a whole room, and he accordion-pleats it, or folds it up onto a canvas. I try to do the same thing with light that he has done with space. I try to fold and pleat as much light as I can onto the canvas. And the way in which, in earlier stages of a painting, I juxtapose light and dark arbitrarily all over the canvas, I think that probably does also relate, certainly to Braque, and to the Cubism of both Picasso and Braque during the heroic years of 1911–12.

EC *I am wondering about the relationship between the artists you choose to write about and your own work, and where Boccioni comes in.*

JG A lot of people have asked me whether I'm influenced by Boccioni. I don't really like Futurist art very much. I think where the Boccioni analogy comes up

is that he was influenced by Cubism and I suppose I am too. To me, it is strange that, as I get old, my painting has become much more active and much more physical. It used to be much more static and much more contemplative, and it has become visceral, and there's a lot of movement in it. I can't account for that.

It surprises me that my own recent painting has become so much more dynamic. When I look at my earlier work, it often looks very static by comparison. Not that I think one thing is better than another. I see no virtue in movement in painting and I see no virtue in static qualities in painting, either.

EC *Do you remember when this happened? Or did it just catch you by surprise? Were you aware of this shift from the more contemplative to the more active taking place?*

JG I'd like to think the contemplative side is still there behind the activity. It has very much to do with my shedding more and more layers of inhibition. In a sense, I led my career backwards – in that one can think of a lot of painters who subsequently became teachers and writers, whereas I was already fairly well established as a writer and was teaching at a time when I was still trying to turn myself into a painter – and I think this set up an awful lot of inhibitions and problems for me, which I hope I have, to a certain extent, shed and overcome.

It's very revealing to me that, if I was teaching at the Courtauld in the afternoon I could work in my studio in the morning, but if I was teaching at the Courtauld in the morning I couldn't work in my studio in the afternoon. I think my work has suffered very much at the hands of critics precisely for this reason too: they think of me still primarily as a writer and an academic and can't conceive that I could also be a painter.

EC *Throughout the time you were working at the Courtauld Institute, did you always think of yourself primarily as a painter?*

JG Yes.

EC *The art history was necessary to keep body and soul together?*

JG Yes, very much, and it's a riddle, isn't it? I'm not particularly gifted as a painter. I'm aware of that and, I suppose, that's why painting interests me so

much. There's always something that I can't do. Art history, by contrast, never bothered me. I never worried about trying to get things right. What I'm saying is that I was naturally gifted as an art historian and not naturally gifted as a painter. My lectures always seemed to go quite well but they never bothered me at all. I'd put aside three days and sit down and just do them.

EC *And is that true of your writing?*

JG Yes, I think it is. It doesn't give me any trouble and I very seldom have to rewrite, whereas I'm constantly reworking my painting and a lot of the pictures go on for five years. I find painting challenges me and absorbs me totally in a way nothing else does, although when I'm writing, obviously, I get excited, occasionally.

EC *You were talking earlier about the gradual loss of inhibition and how this might relate to the changes in your work. Would you describe your work now as more emotionally expressive because it's more dramatic?*

JG I think, probably, I would – yes. It's odd, also – and I think it's true of a lot of artists – that I know what I don't want, but I'm not always sure what I do want.

EC *What don't you want?*

JG I don't want my art to be about myself. I certainly don't want it to be autobiographical in any way. In some of my recent paintings – and this has come with them becoming more dynamic and visceral – I don't like the swooning quality they sometimes acquire. I either go into the canvases again or I destroy them. A lot of works I've destroyed because of this. It's like Scriabin in music. It can be quite beautiful, but… It's very difficult with abstract art too because I've been painting long enough that I can make a painting look alright. But that's not enough. It's got to give one back some sort of psychological truth – it's got to have some sort of psychological impact on its own, independent of oneself.

Also, in my more recent painting, I'm much less concerned with achieving formal stability – although I always demand formal stability in other artists, and the artists I most like are the ones with strong formal values.

It's part of getting old: one realises that, sometimes, one's weaknesses are simultaneously one's strengths. There's a wonderful story of Matisse saying that there were certain things in his own painting that bothered him and all of a sudden he realised that they were him – that was him as a painter.

What does worry me slightly is that, obviously, as one gets older, one has less energy and less physical strength. I'm aware of the fact that I find the processes of painting more difficult and yet, at the same time, my painting is becoming so much more visceral and so much more overt. It's odd that.

EC *Are you conscious, for example, of working on a smaller scale than you actually want to? Or are you happy with the scale that you work on?*

JG I'd like to be able to come down in scale, but I can't. The small paintings that I have achieved I found harder to paint than the big ones. The large scale has a lot to do with my early background [in Mexico] of looking at so much mural painting, and of course it also has everything to do with American painting.

One of the problems for contemporary abstraction is that American painting of the 1940s and 50s relied so much on scale, but at the same time took up an awful lot of room – literally, wall space. There's so much abstract painting being done at present – including my own work – that has no destination.

EC *Is that why you would like to come down in scale, because of the problem for anybody housing the paintings? Or do you feel they would be stronger if they were smaller?*

JG It's difficult to say. I'd like to come down in scale because it would be physically less demanding, and the work would obviously be more saleable and would find its destination. And yet the work that I feel most satisfied with is on quite a big scale.

It has a lot to do again with body imagery. I feel you've got to be able to get into the paintings and identify with them with your whole body – with your totality of experience – and not just metaphorically and with your eyes.

EC *I was wondering whether, in fact, you actually wanted to go bigger, rather than go smaller.*

JG Well, at one point, I did and those pictures never found homes. There's an awful lot of them just rolled up in my studio, and that's not a unique situation at all. I think most abstract painters – even very successful ones – have vast stores of paintings that will probably never be seen. It's a very strange situation.

EC *The pastel drawings – although drawing is an odd word for them – why do you do them?*

JG Well, I love pure pigment. As I said, I'm not naturally gifted, but I think what I do have is a very strong colour sense. Colour, of course, is very hard to handle on a very large scale, whereas in the works on paper I just delight in pure pigment.

EC *With your own painting, the layering of the surfaces is extremely important. Up close, one gets a very different experience than from standing back at a distance. One starts seeing extraordinary bubbling effects – almost volcanic. Is that deliberate or accidental?*

JG I think it comes through working on them over such long periods and also from my method of work. Obviously, when painting, one is close-up and one becomes very involved with the actual act of painting, and when one stands back one looks at the totality, and then one begins altering things. But I think it also has something to do with one of the problems of abstract painting – of ensuring that it has psychological depth.

I find it very hard to talk about my own painting. It may well be the result of having talked so much about other people's painting that I find it easier to talk about other people's painting than I do about my own.

EC *You said that you didn't want your painting to be about yourself.*

JG Inevitably it is about myself because I make it. All artists are, by definition, narcissists, otherwise one wouldn't spend one's life looking into a mirror, as it were. But I'd like to think that I paint myself out of my pictures. I enjoy autobiography in other artists' work. You and I have worked on the most autobiographical of all artists [Picasso] and he gives one endless sustenance. But in my own case, the work that I do that satisfies me – not that I'm ever truly

satisfied – is work that confronts me independently, in which I don't recognise myself. I know I'm in it because I did it, but equally it confronts me objectively, from outside.

EC Do the paintings actually begin with memories? Are there specific experiences, memories, feelings, and so forth, that you, as it were, get rid of in the process of painting?

JG To a certain extent, but I think it's true of most abstract painters that eventually each painting is born out of another painting, rather than an outside experience. I think one of the tremendous dilemmas of abstract art is how to keep it emotionally alive and relating to experience and to certain human qualities, because it can so easily just become totally self-referential. I think all art is born to a greater or lesser extent out of other art, but, obviously, if you're working in a figurative way, you're open to so much more experience and so much more other art too. I don't feel one kind of painting is ever better than another kind of painting, but I think it is much easier to keep a representational idiom alive than it is to keep an abstract idiom alive.

I sometimes worry terribly, for I know there's a sense in which I just paint the same picture over and over again. That's probably one of the reasons why a long working process is so important. Although some of them may look superficially alike, it's the long working process that gives each painting, to me at least, its separate psychological identity.

EC You've never actually felt tempted – after all, you had a figurative background – to break back?

JG I haven't – no. I feel very strongly that when I went into abstraction, I reached a point of no return. But I do admire, and envy, artists who find it possible to weave back and forth because it can be exciting and very productive and it is a great way, also, for self-renewal.

EC When you actually made that break, and committed yourself once and for all…

JG Took the pledge…

EC Was it driven by a feeling that that was the right way for a late twentieth-century artist?

JG I think it did have everything to do with my recognition of what was happening in American art. When I encountered American art in the 1940s and above all in the 1950s, I just thought to myself, this is the most important thing that's going on in painting today and, naturally, I identified with it. But it also took me a long time to find my way into abstraction.

It never ceases to amaze me – given the fact that abstraction has been around for so long – that it was only artists of a generation after my own who felt that they could go directly into abstraction and who didn't have to find their way into it, and I think it landed an awful lot of them in a mess. It was very exciting what they were doing, and they were excited about the possibilities of painting, but at a certain moment they had to stand back and say, 'What is it about?' – and a lot of them didn't know. They painted a lot of pictures and suddenly didn't know what the pictures were about. I think that's why there's been a genuine hiatus in the progress of abstract art. I think abstract art has to rediscover itself, because all art has got to be about something, and not just about itself. It's a big problem, isn't it?

I do sometimes worry – well, I often worry – about having painted myself into a corner, as it were. It's a dilemma that faces an awful lot of abstract artists. A lot of them kill themselves because of it – Rothko is a classic example, of course. I mean, he literally painted himself into a dead-end. Having discovered so much and done works of such great beauty, he just couldn't find a way of pushing it further.

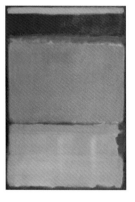

Fig.11
Mark Rothko
No. 10, 1950
Oil on canvas
229.6 × 145.1 cm
Museum of Modern Art, New York,
Gift of Philip Johnson

EC What do you think of the very late black and grey ones? Do you see them as really a dead-end?

JG Yes. I think they are some of the most tragic paintings that have ever been painted and they're not good paintings either.

EC You say art is about other art: when you're looking at other art, are you looking at it with a view to it being a stimulus?

JG No, I wish I could. It's always a stimulus to me, but I always look at it absolutely on its own terms, and it just catches me and holds me. I never look at art thinking, is there something I could use in that? I wish I could, but again, I think that is much easier for figurative painters.

My friend Kitaj is a very good example. He is constantly open to other art that can help him, that he can use – either directly by quoting it, or because there are certain pictorial devices that he feels he can incorporate into his own work. I envy him because I think he is an artist who doesn't have to worry about feeling he is repeating himself.

Paintings

Nude/Desnudo Gris, 1959
Oil and mixed media on board
89 × 70 cm
John Golding Artistic Trust

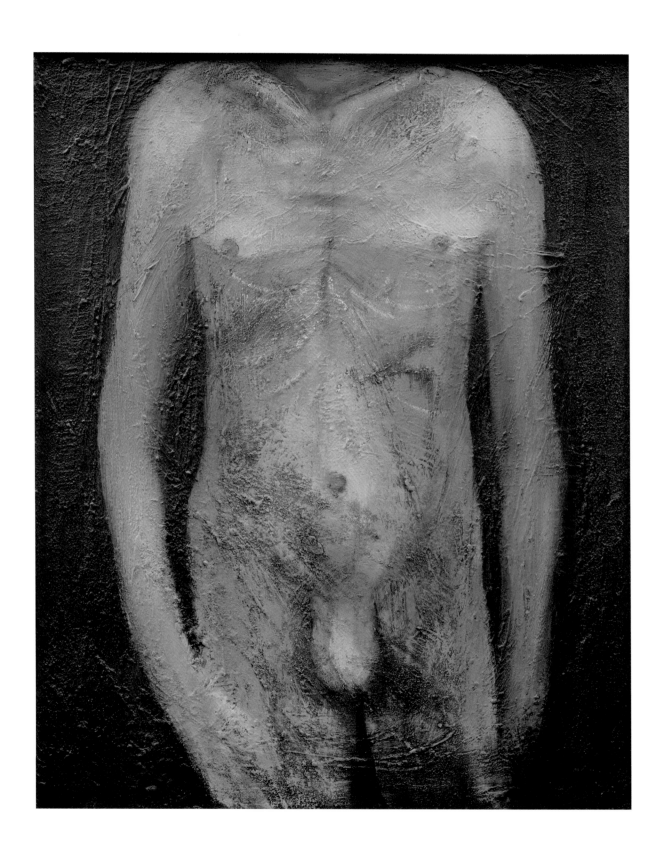

Standing Nude, 1959
Oil and mixed media on board
107 × 64.4 cm
John Golding Artistic Trust

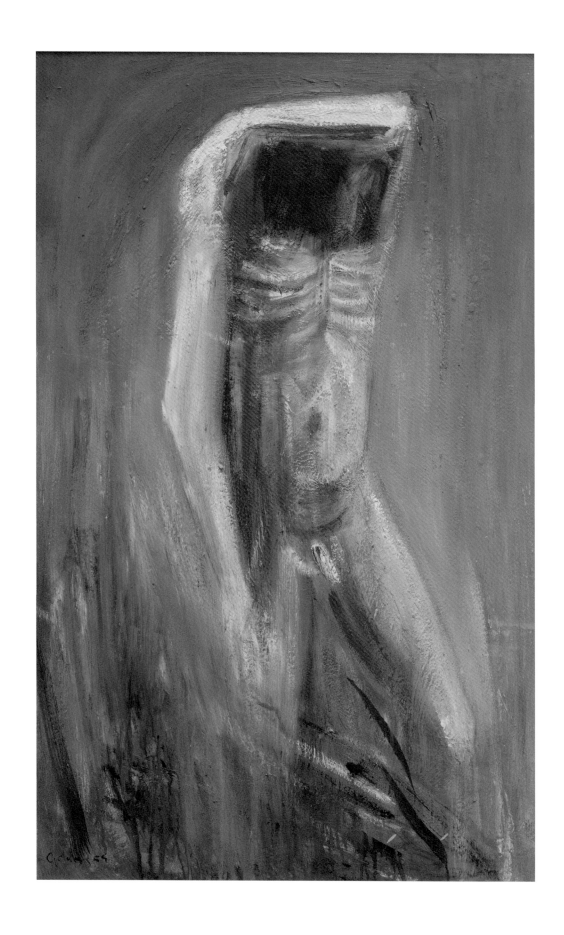

Charon, 1960
Oil and mixed media on board
148.6 × 109 cm
Yale Center for British Art, Gift of the John Golding Artistic Trust

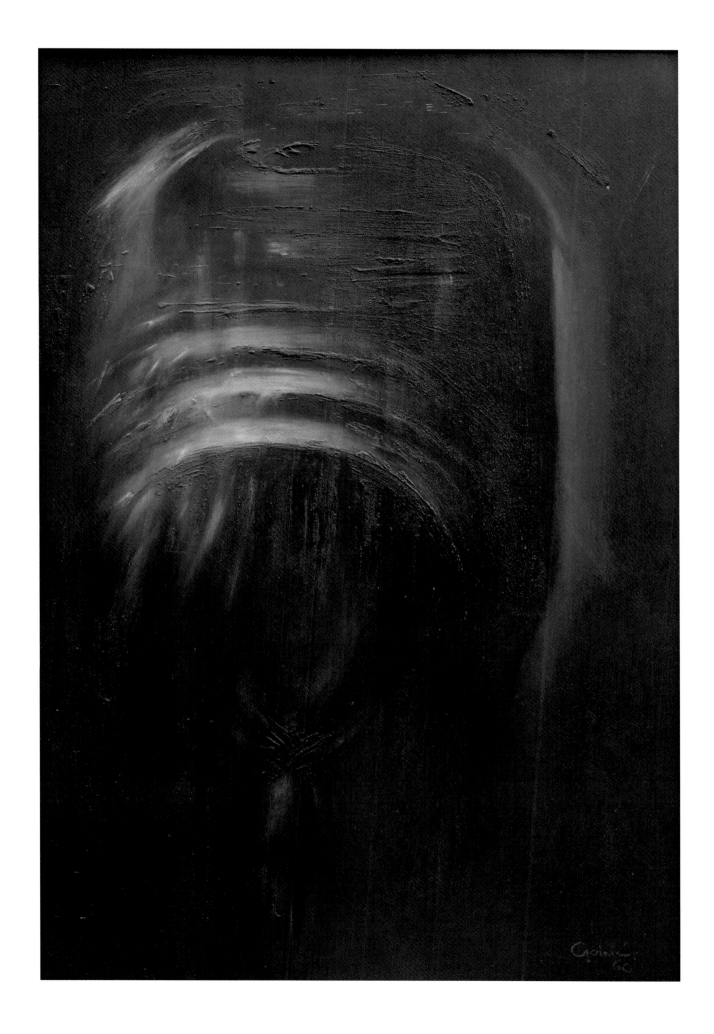

Cliff Dwellers, 1961

Oil and mixed media on board

127 × 187 cm

Yale Center for British Art, Gift of the John Golding Artistic Trust

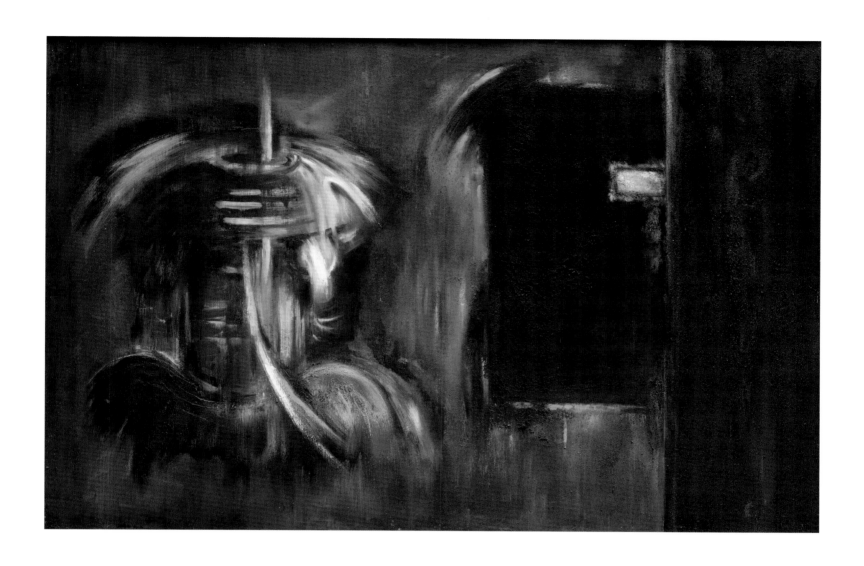

Figures in a Landscape, 1961
Oil and mixed media on board
122 × 184 cm
John Golding Artistic Trust

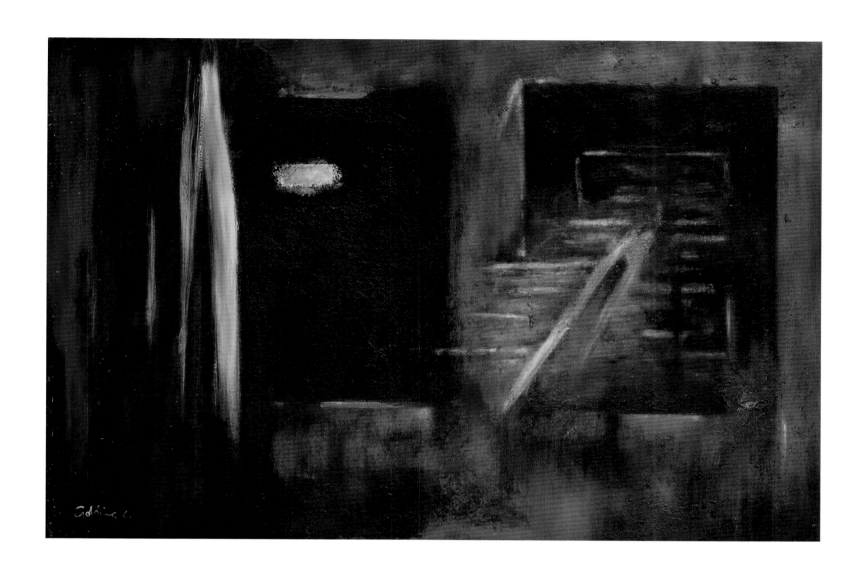

The Couple/Blue, 1962
Oil and mixed media on board
152.3 × 91.4 cm
Private Collection

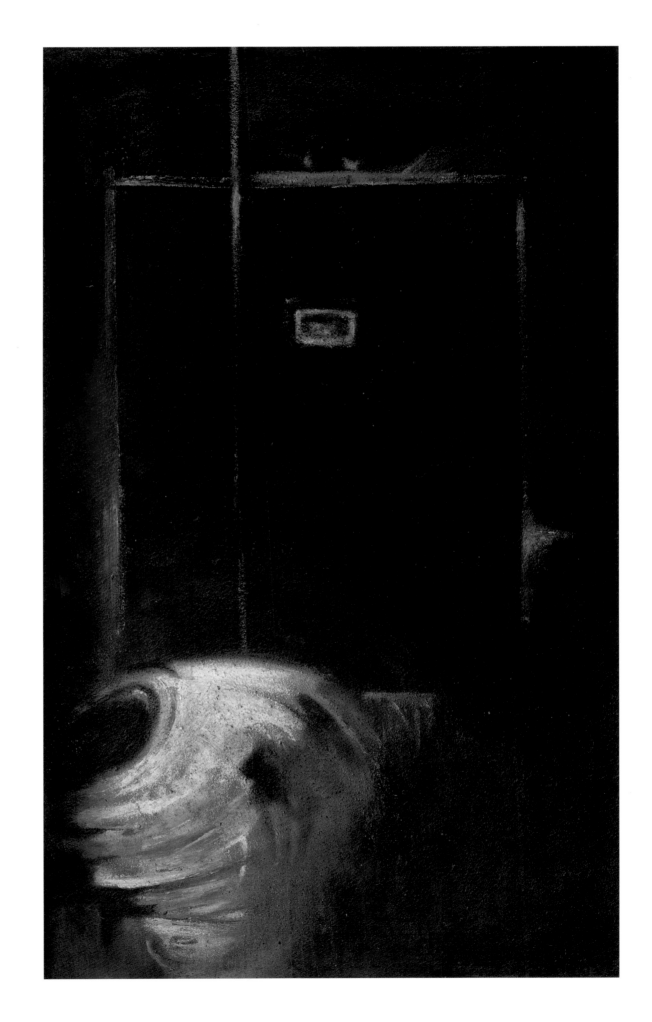

Figure Study in Blue and Orange, 1963
Oil and mixed media on board
132 × 92 cm
John Golding Artistic Trust

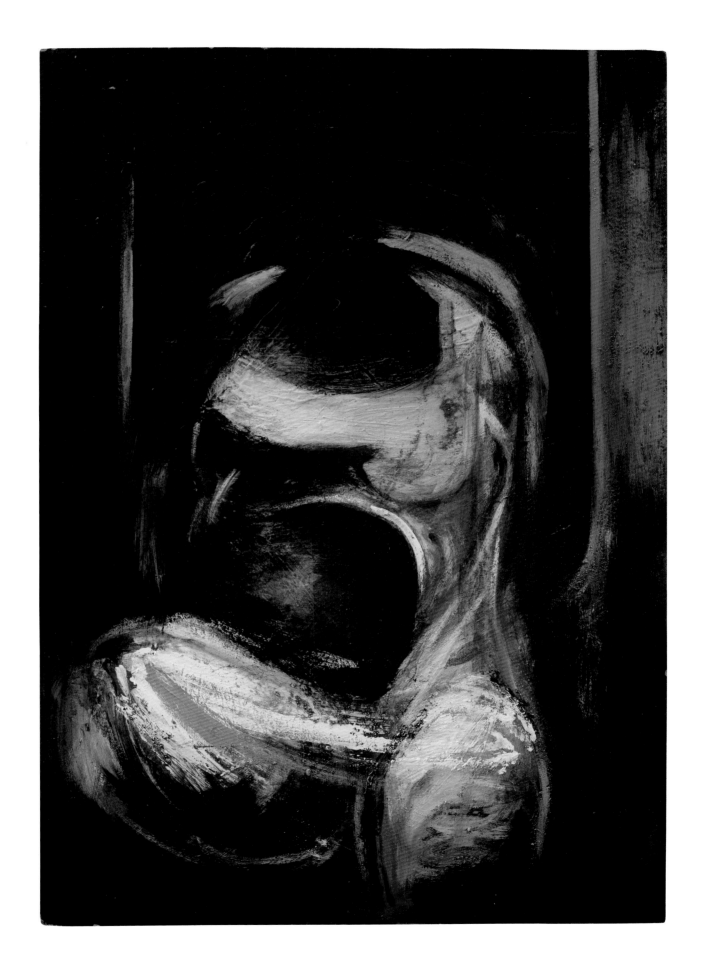

Untitled, 1965
Acrylic on canvas
142.5 × 188 cm
National Galleries of Scotland, Edinburgh

Portman Square, 1965–66
Acrylic on canvas
162.6 × 162.6 cm
Private Collection

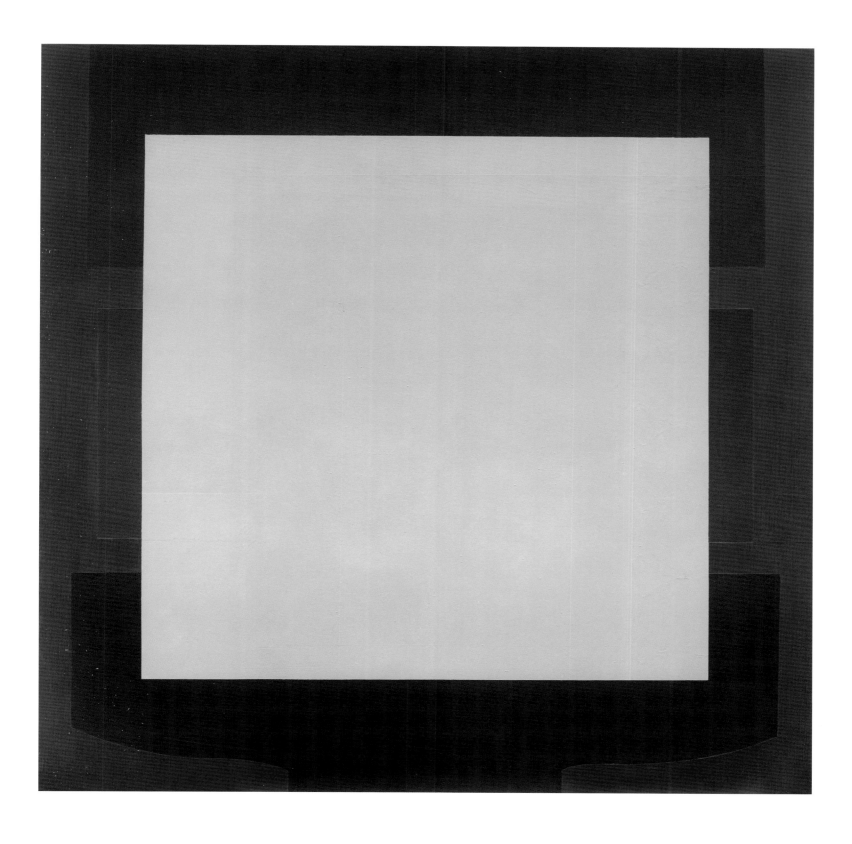

Square II, 1965–66
Acrylic on canvas
162.3 × 162.3 cm
John Golding Artistic Trust

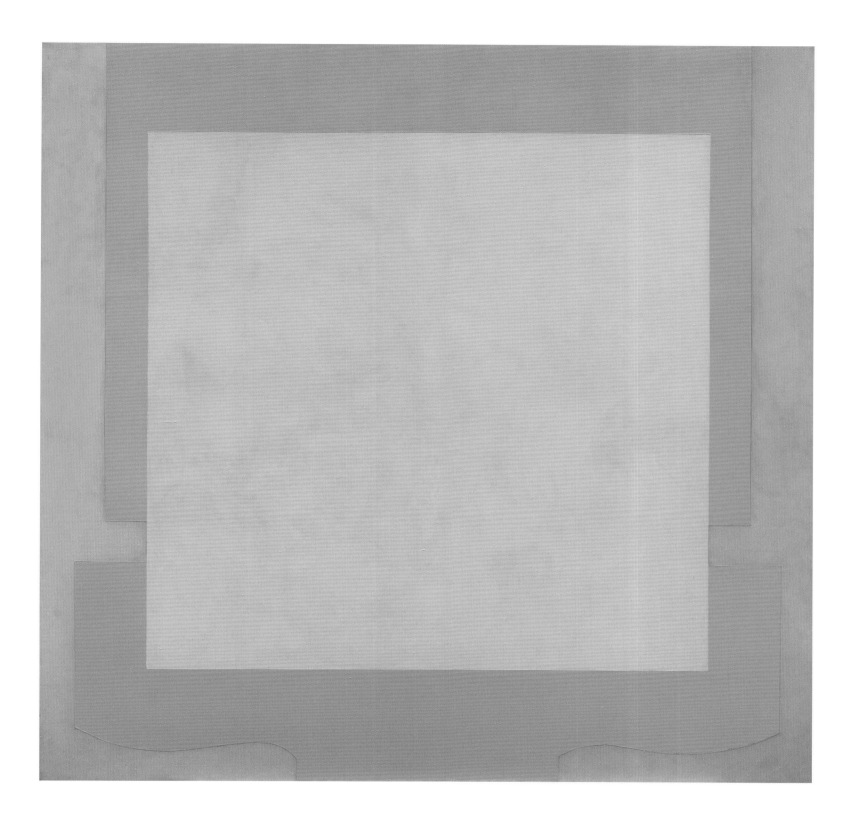

Niobe, 1966
Acrylic on canvas
162.5 × 213 cm
John Golding Artistic Trust

Vol de Nuit, 1966
Acrylic on canvas
141 × 185.5 cm
John Golding Artistic Trust

Gymnopédie, 1966
Acrylic on canvas
163 × 227 cm
Yale Center for British Art,
Gift of the John Golding Artistic Trust

Untitled, 1967
Acrylic on canvas
174 × 135.9 cm
John Golding Artistic Trust

Blue Predella, 1967
Acrylic on canvas
228.6 × 165.1 cm
John Golding Artistic Trust

Purple and Red Abstract, 1967
Acrylic on canvas
229 × 165 cm
John Golding Artistic Trust

Untitled, 1969
Acrylic on canvas
152.4 × 152.4 cm
John Golding Artistic Trust

Untitled 69, 1969
Acrylic on canvas
152.4 × 152.4 cm
John Golding Artistic Trust

B V, 1971
Acrylic on canvas
213 × 365 cm
John Golding Artistic Trust

C III, 1972–73
Acrylic on canvas
213 × 305 cm
John Golding Artistic Trust

C V, 1972–73
Acrylic on canvas
198.1 × 213.4 cm
Yale Center for British Art, Gift of the John Golding Artistic Trust

C V, 1973
Acrylic on canvas
213.4 × 304.8 cm
Tate

Untitled, 1974
Acrylic on canvas
71.1 × 91.4 cm
John Golding Artistic Trust

Untitled, 1974
Acrylic on canvas
45.7 × 61 cm
Private Collection

D (E. S.) VII, 1975
Acrylic on canvas
182.9 × 243.8
John Golding Artistic Trust

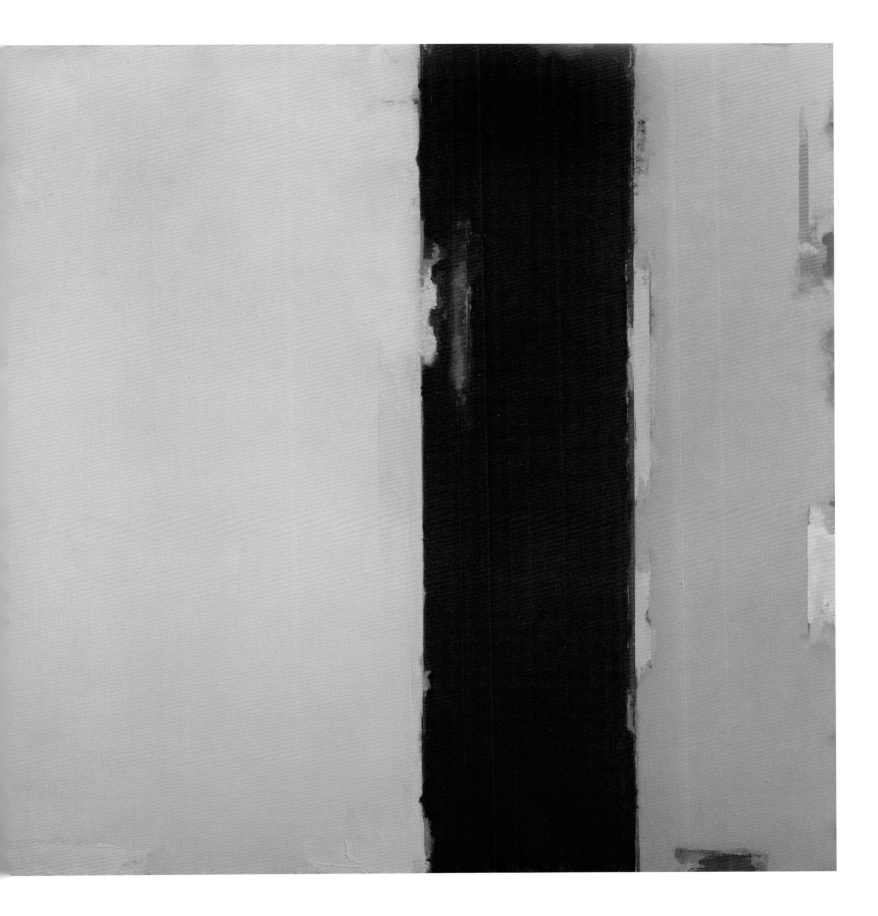

D (C. S.) VI, 1975
Acrylic on canvas
182.9 × 243.8 cm
Arts Council Collection, Southbank Centre, London

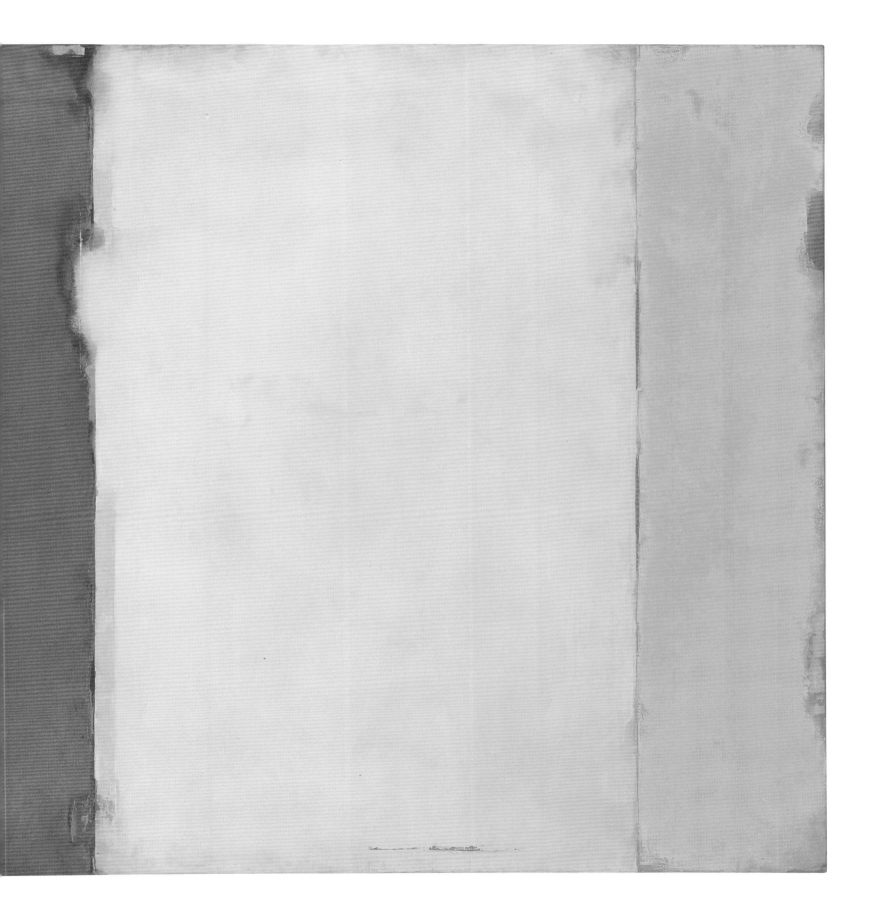

E (U. B.) VI, 1976
Acrylic on canvas
142.2 × 195 cm
Yale Center for British Art, Gift of the John Golding Artistic Trust

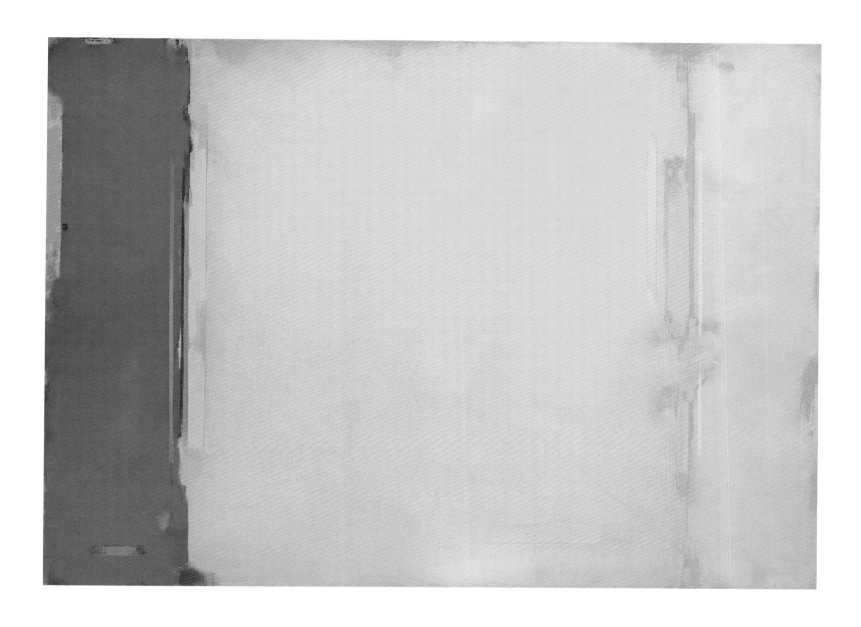

E (W. Y.) VII, 1976–77
Acrylic on canvas
175.3 × 251.5 cm
John Golding Artistic Trust

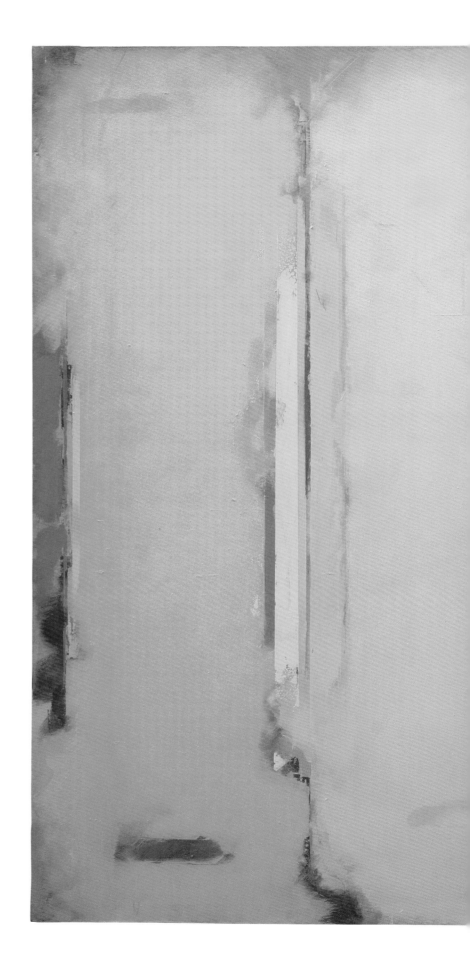

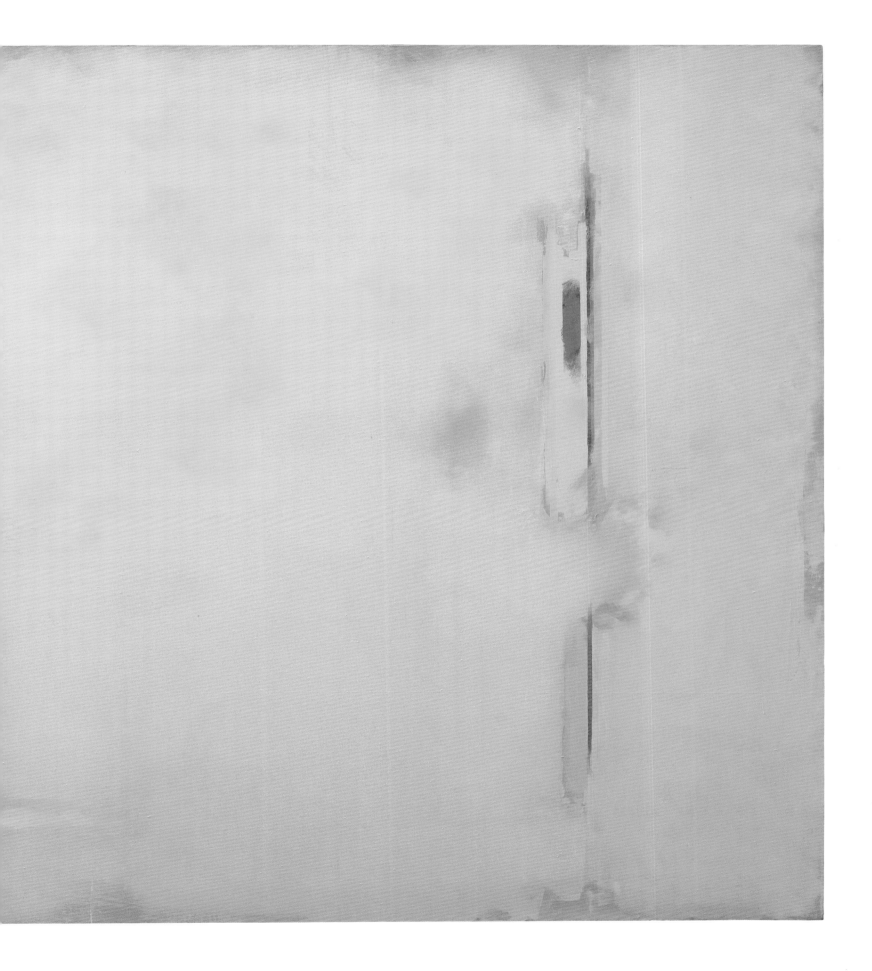

F (A. S.) I, *1977*
Acrylic on canvas
167.6 × 274.3 cm
Private Collection

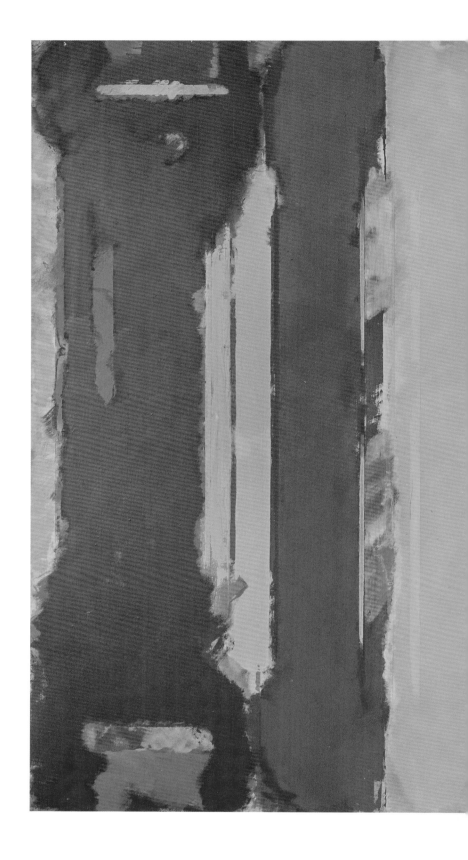

F (W. Y.) III, 1977
Acrylic on canvas
167.5 × 254 cm
Hunterian Art Gallery, Glasgow

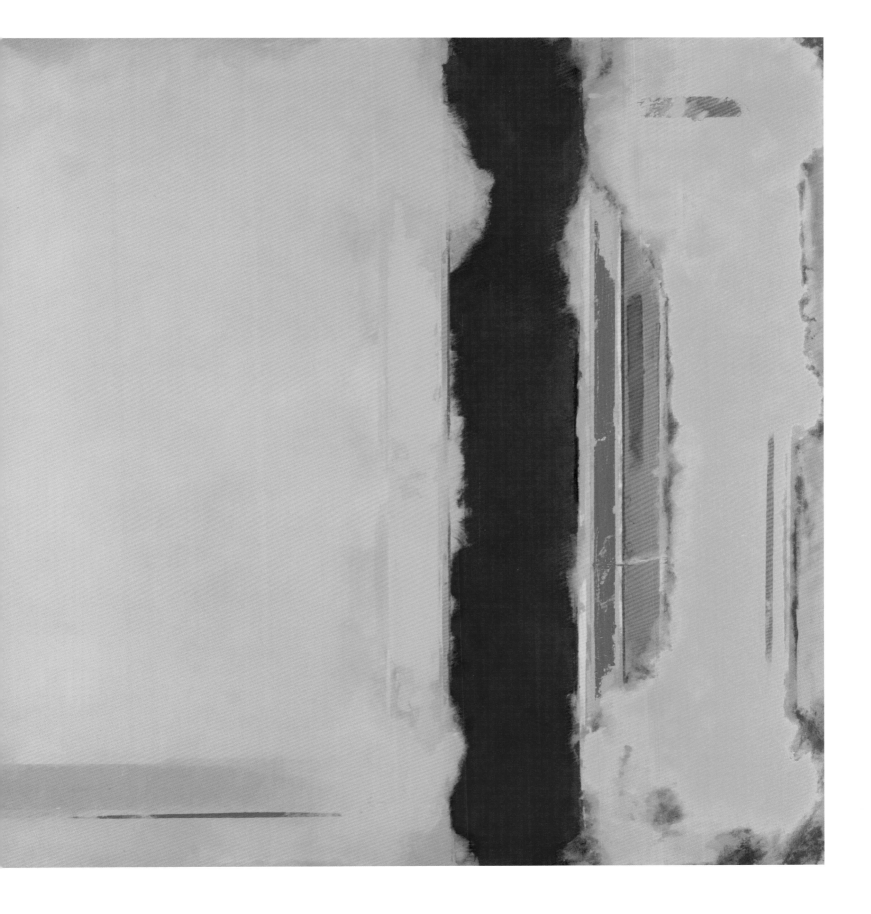

F (S. C.), 1977–78
Acrylic on canvas
129.5 × 195.6 cm
John Golding Artistic Trust

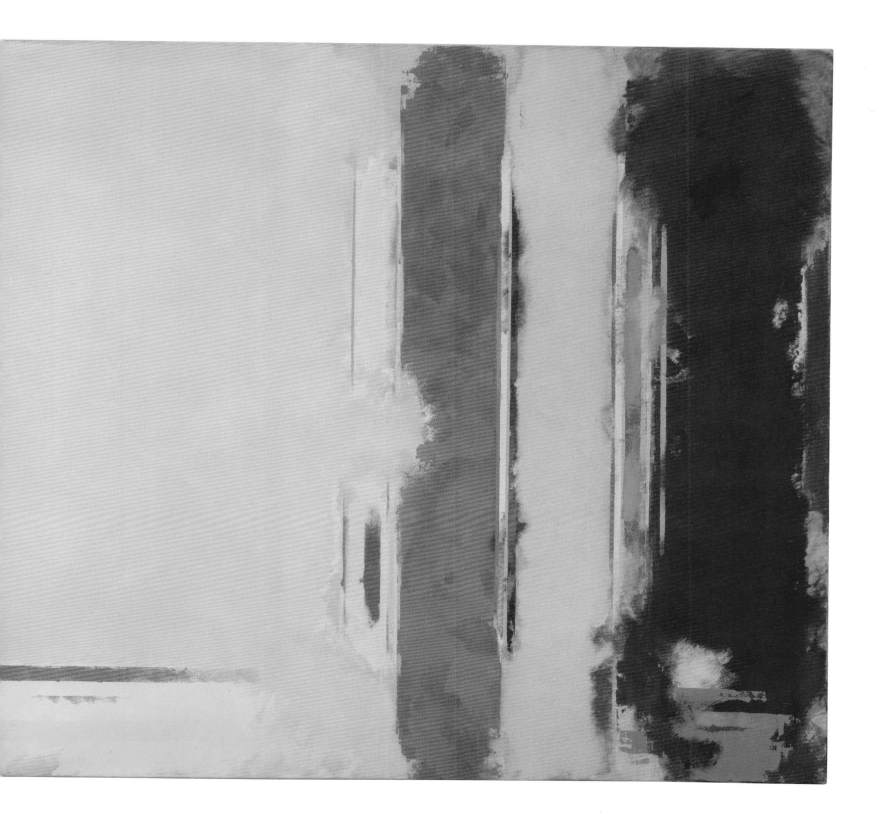

G III (Y. B.), 1978–79
Acrylic on canvas
132 × 203 cm
John Golding Artistic Trust

G (G. I.) VII, 1979
Acrylic on canvas
132 × 204 cm
Private Collection

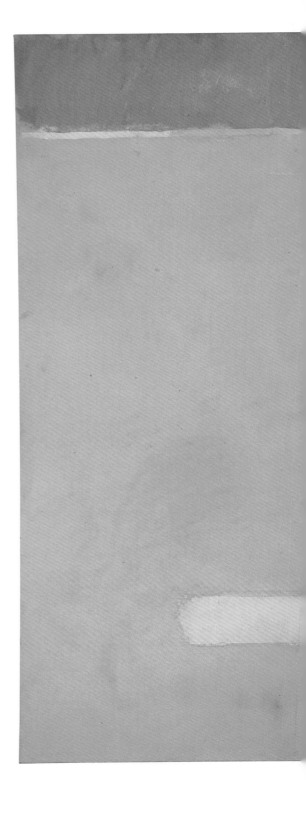

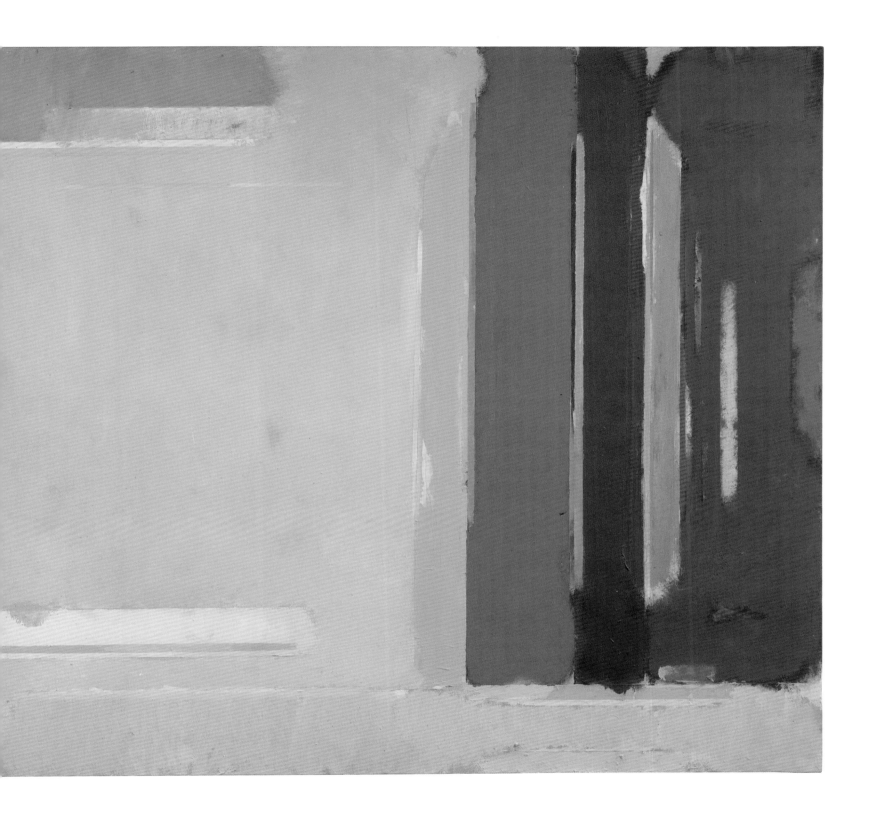

G (M. B.) IX, 1979
Acrylic on canvas
152.5 × 244 cm
John Golding Artistic Trust

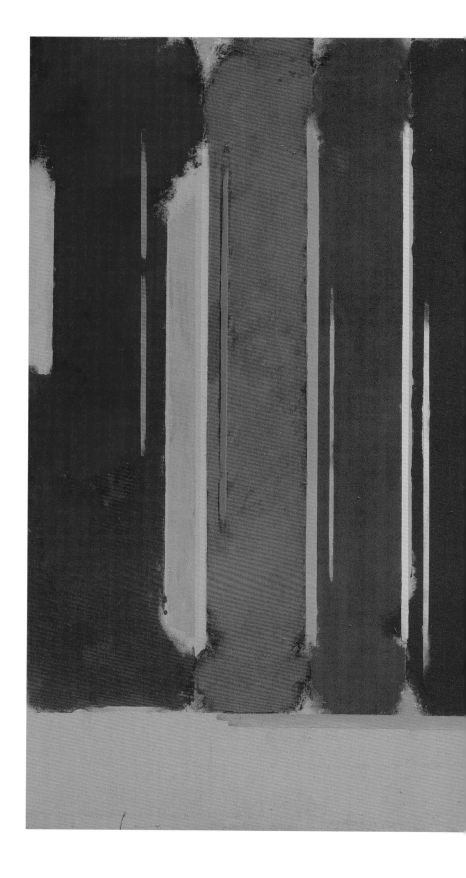

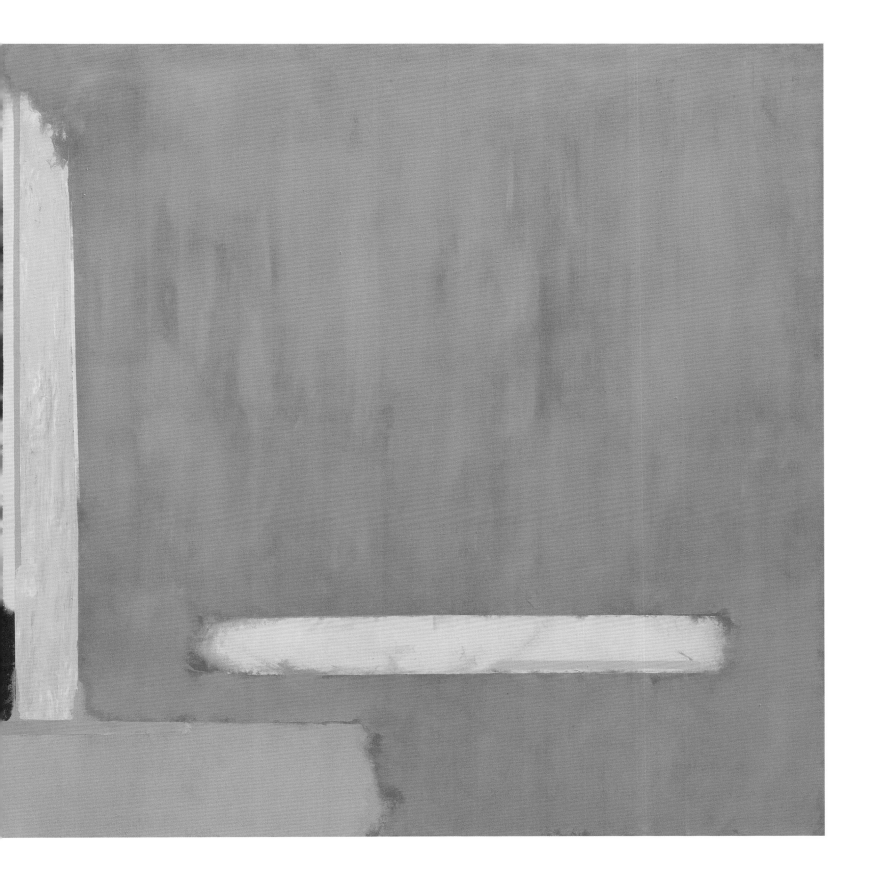

G (P. O.) X, 1979
Acrylic on canvas
142.2 × 228.6 cm
John Golding Artistic Trust

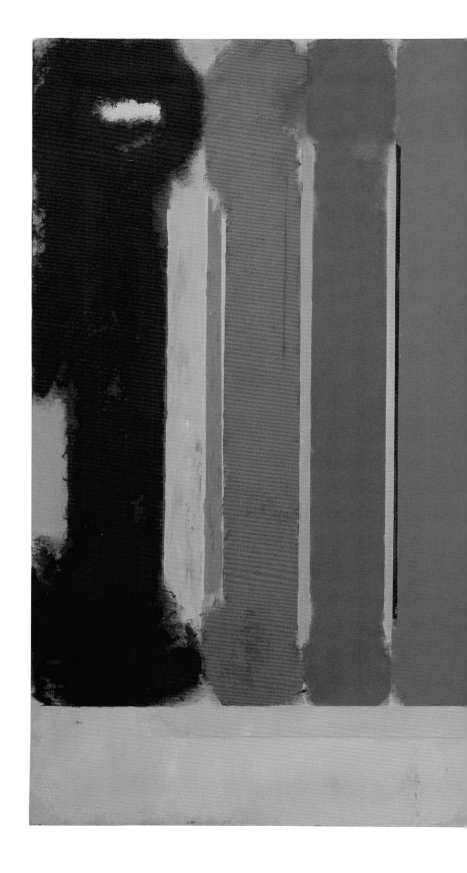

G (B. E.) XI, 1979
Acrylic on canvas
148 × 194.9 cm
Private Collection

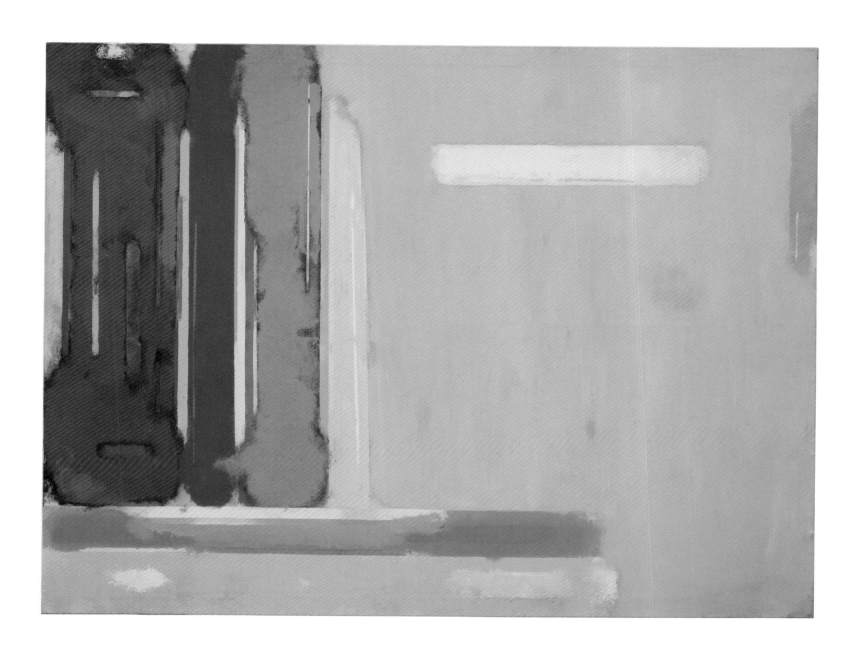

H. 8 (Yellow Thunder), 1982
Acrylic on canvas
152.4 × 213.4 cm
John Golding Artistic Trust

H. 12 (Danae), 1982
Acrylic on canvas
152.5 × 217 cm
Private Collection

H. 3 (The Archer), 1982
Acrylic on canvas
133 × 213 cm
John Golding Artistic Trust

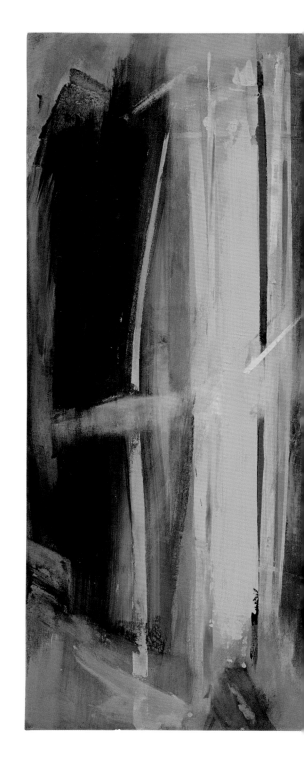

H. 14 (Chrome Drifts), 1983
Acrylic on canvas
147.3 × 218.4 cm
John Golding Artistic Trust

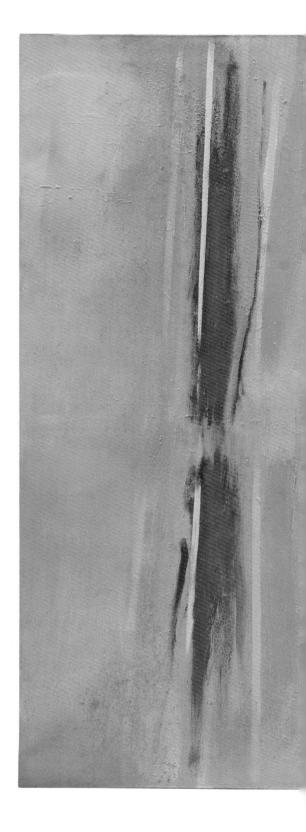

H. 18 (Blue Grey), 1983
Acrylic on canvas
147.3 × 219.7 cm
Private Collection

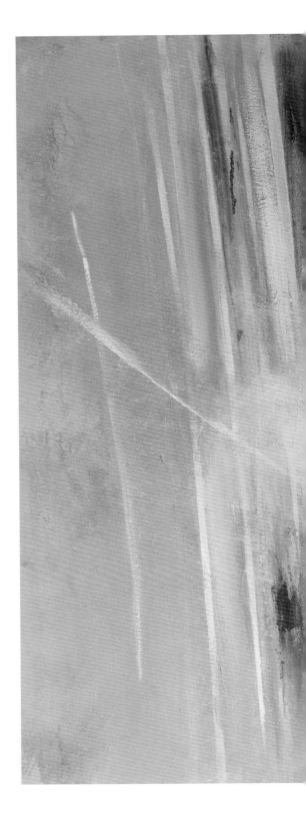

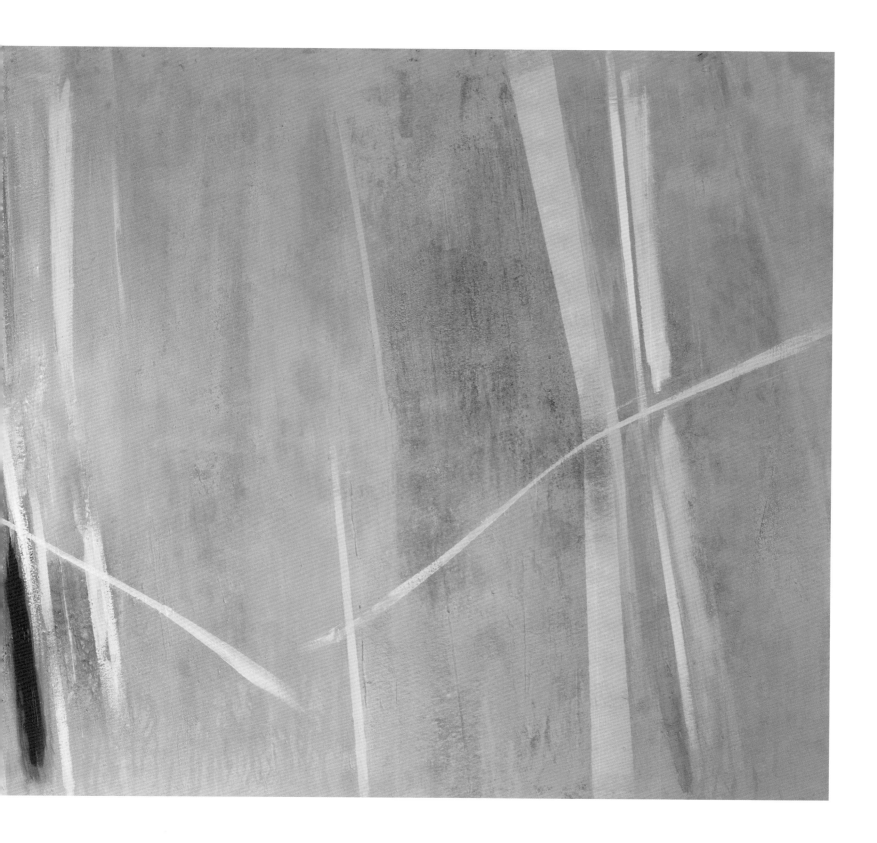

H. 20 (The Secret), 1982–85
Acrylic on canvas
152.4 × 208.3 cm
John Golding Artistic Trust

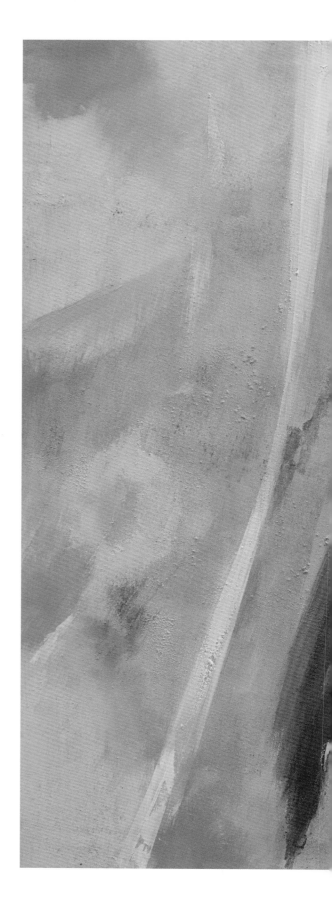

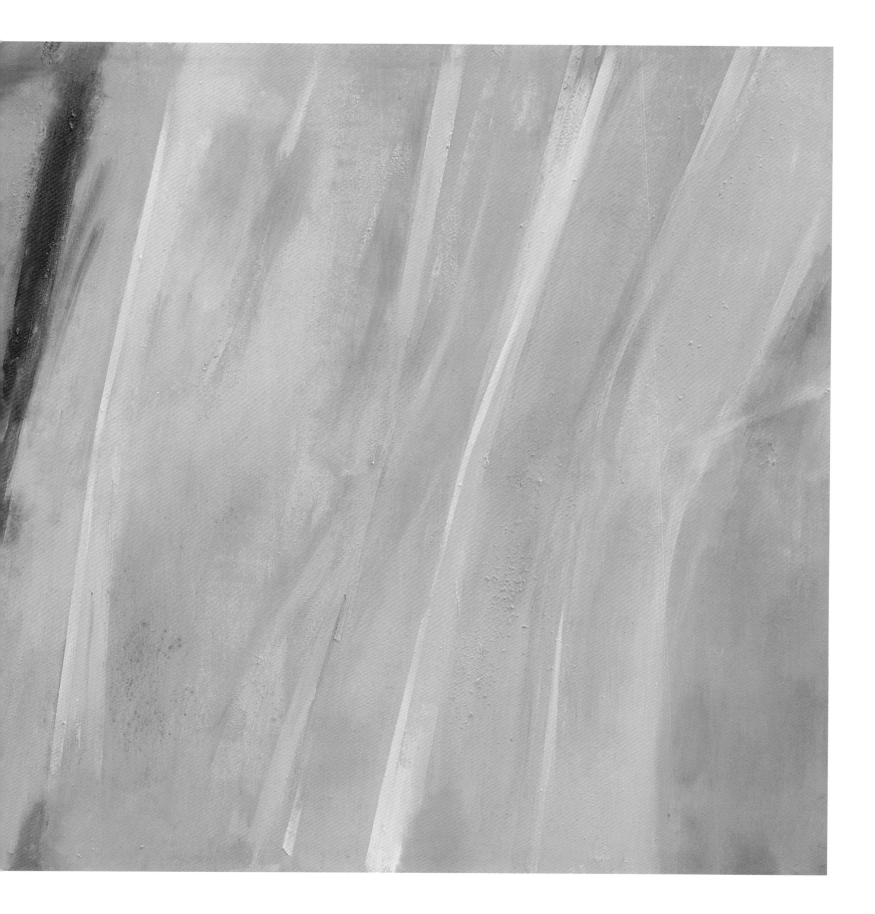

H. 20 (Veronese Blue), 1983–84

Acrylic on canvas

142.2 × 193 cm

Yale Center for British Art, Gift of the John Golding Artistic Trust

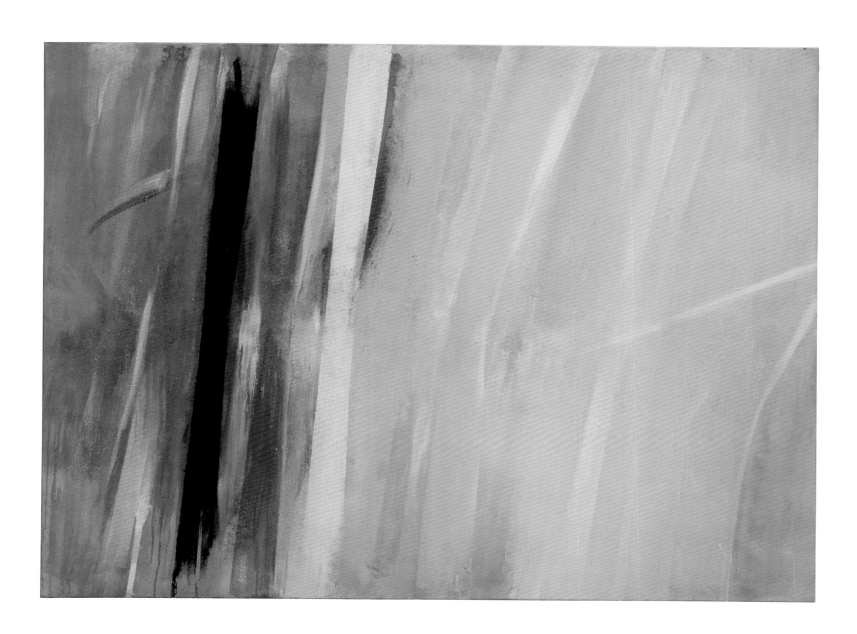

S. H. 3 (Quarried Light), 1983
Acrylic on canvas
122 × 152.5 cm
John Golding Artistic Trust

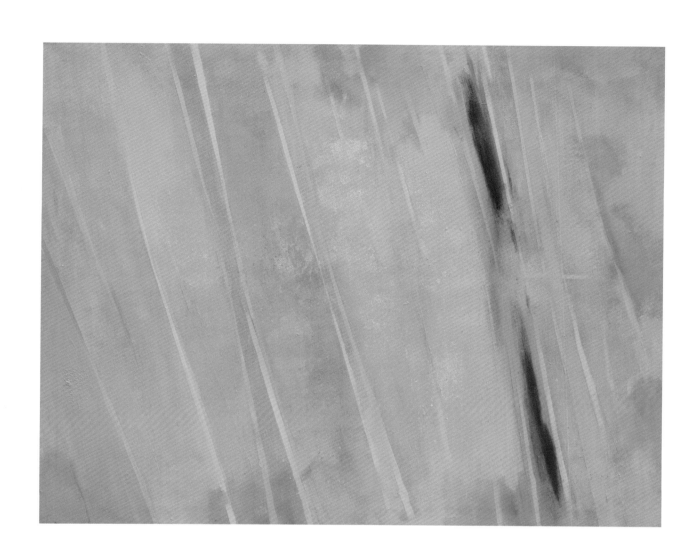

I. 1 (Splintered Light), 1985
Acrylic on canvas
152 × 208 cm
John Golding Artistic Trust

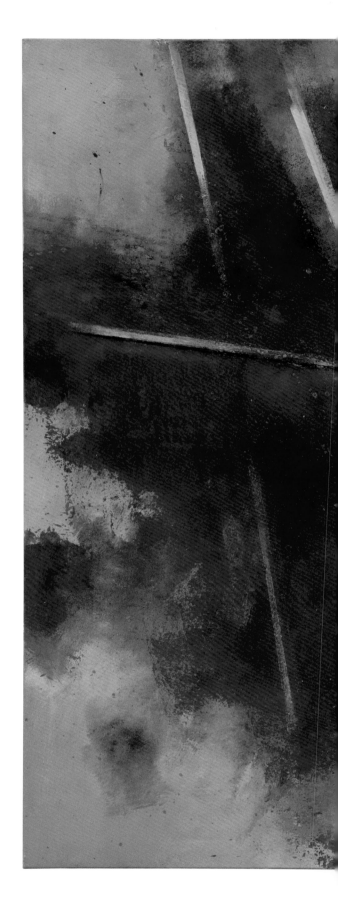

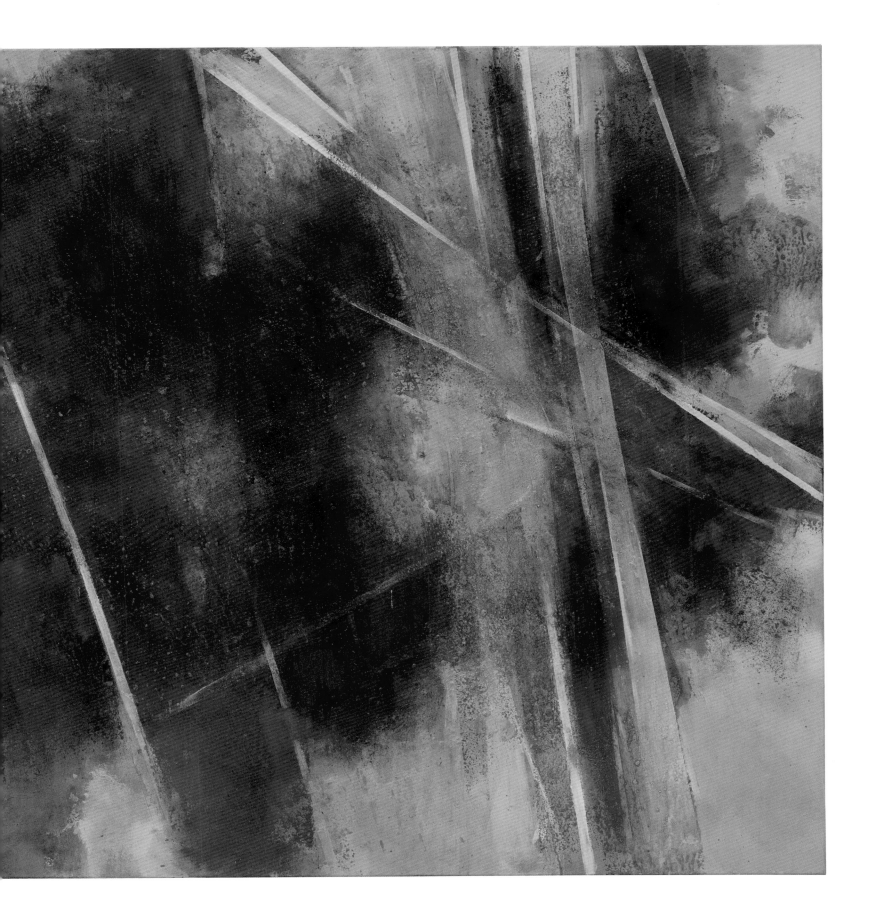

I. 4 (Blue Mountain), 1985
Acrylic on canvas
142.2 × 167.6 cm
John Golding Artistic Trust

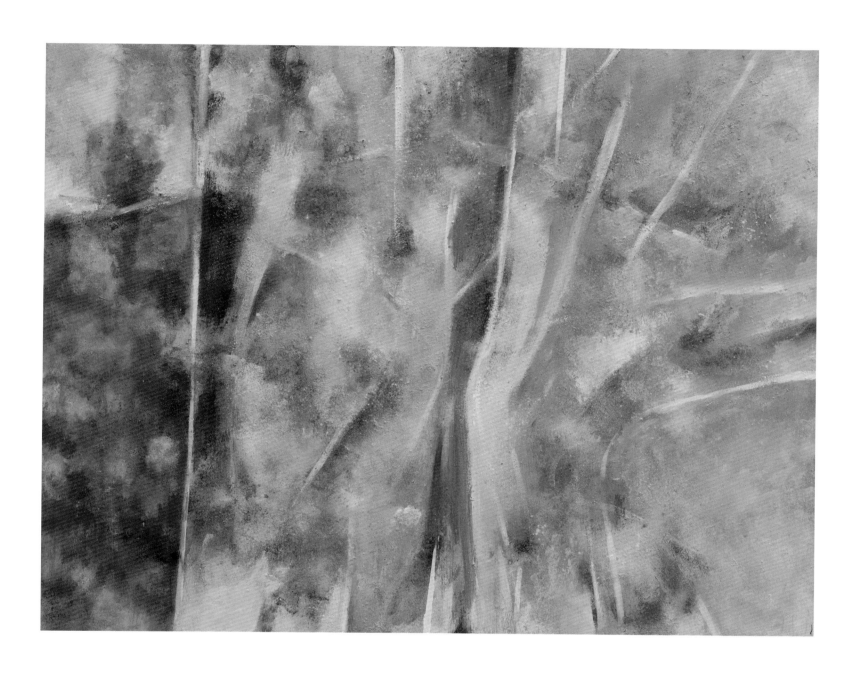

S. 15 (Peach and Gold), 1985
Acrylic on canvas
121.9 × 152.4 cm
Private Collection

I. 9 (Blaze), 1986
Acrylic on canvas
152.4 × 198.1 cm
Yale Center for British Art, Gift of the John Golding Artistic Trust

I. 6 (Light from Troy), 1986
Acrylic on canvas
163 × 223.5 cm
John Golding Artistic Trust

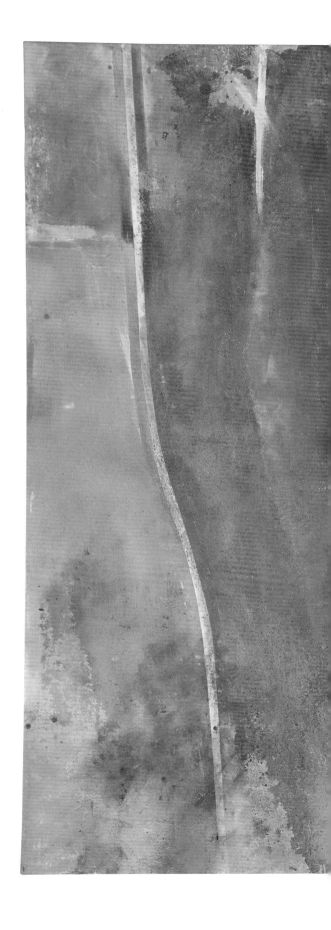

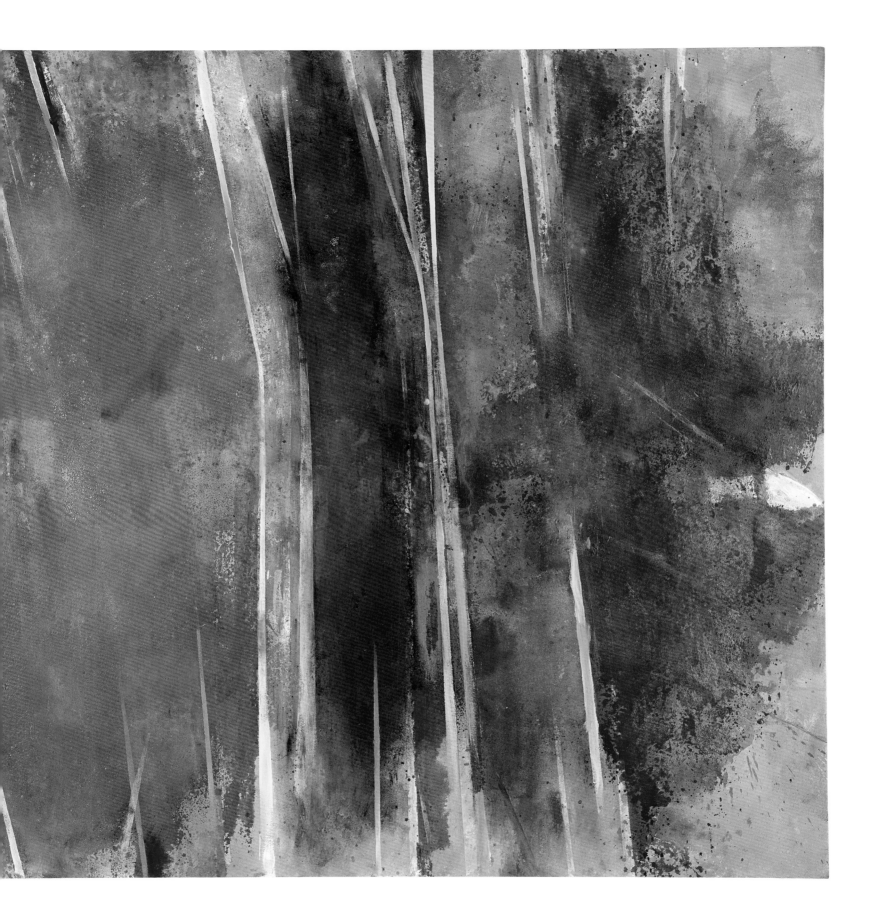

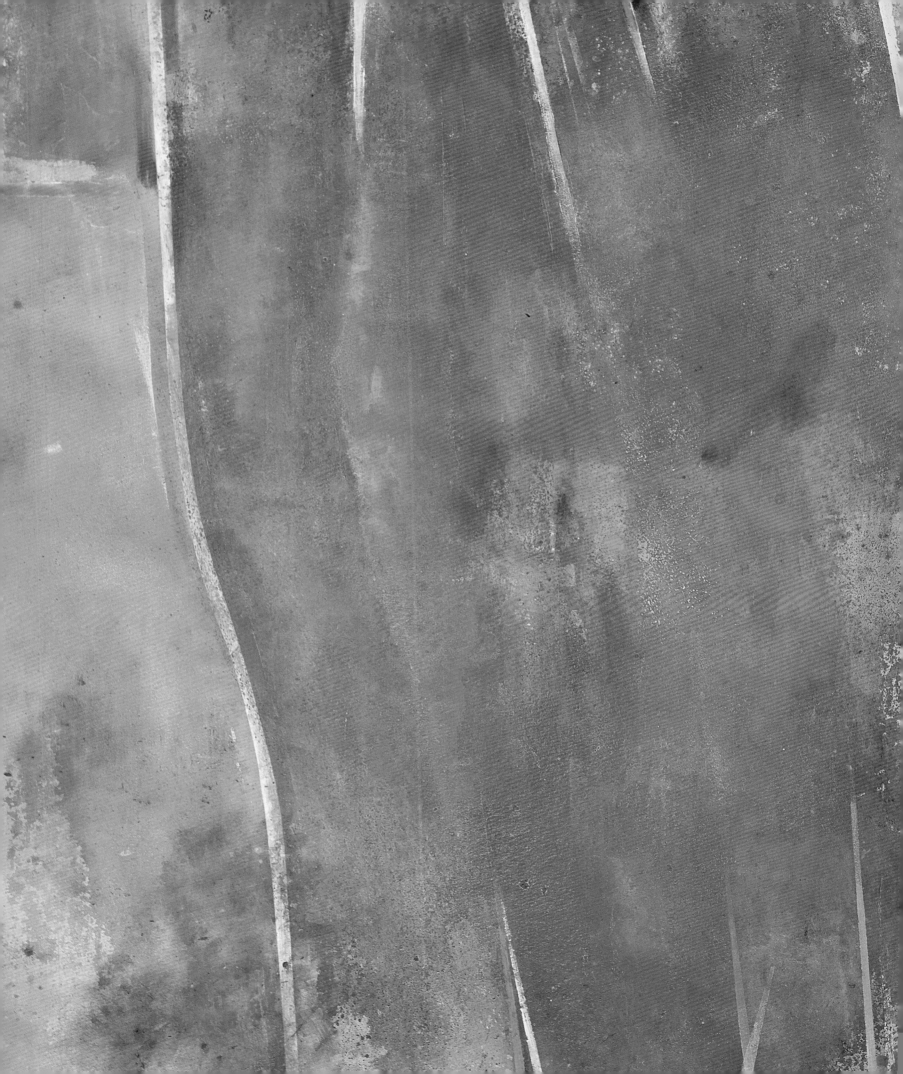

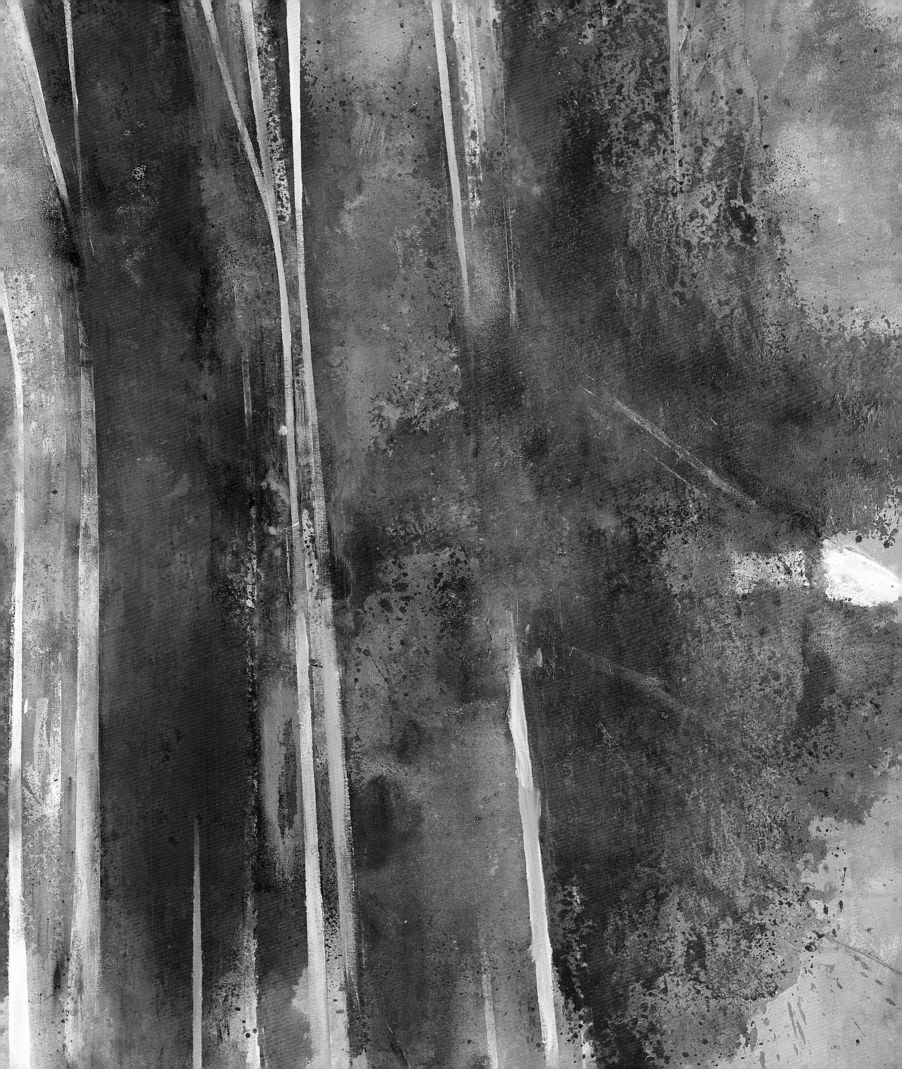

I. 13 (Quiver), 1987
Acrylic on canvas
142.2 × 188 cm
John Golding Artistic Trust

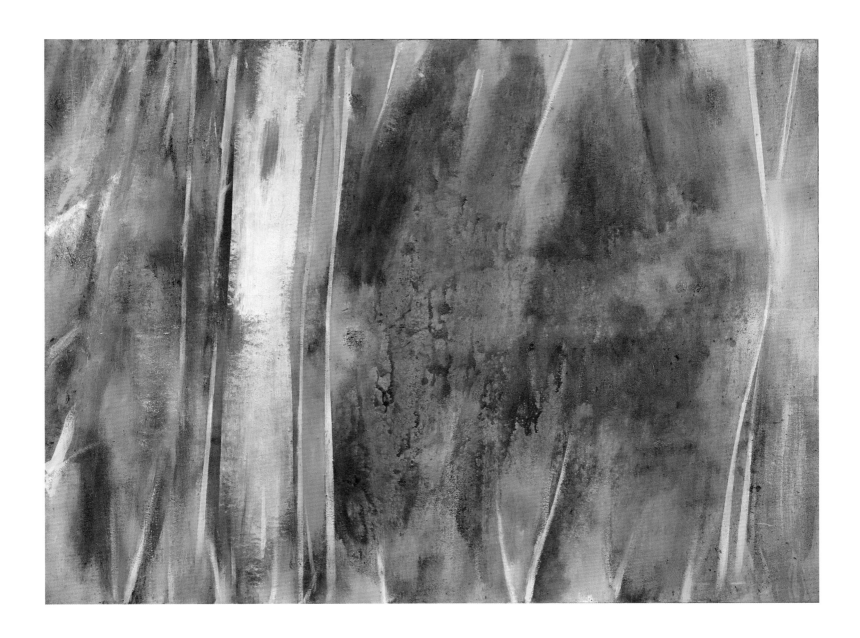

J. 4 (Tabachin), 1988
Acrylic on canvas
152.4 × 198.1 cm
John Golding Artistic Trust

J. 8 (Body), 1989
Acrylic on canvas
162.6 × 223.5 cm
Yale Center for British Art, Gift of the John Golding Artistic Trust

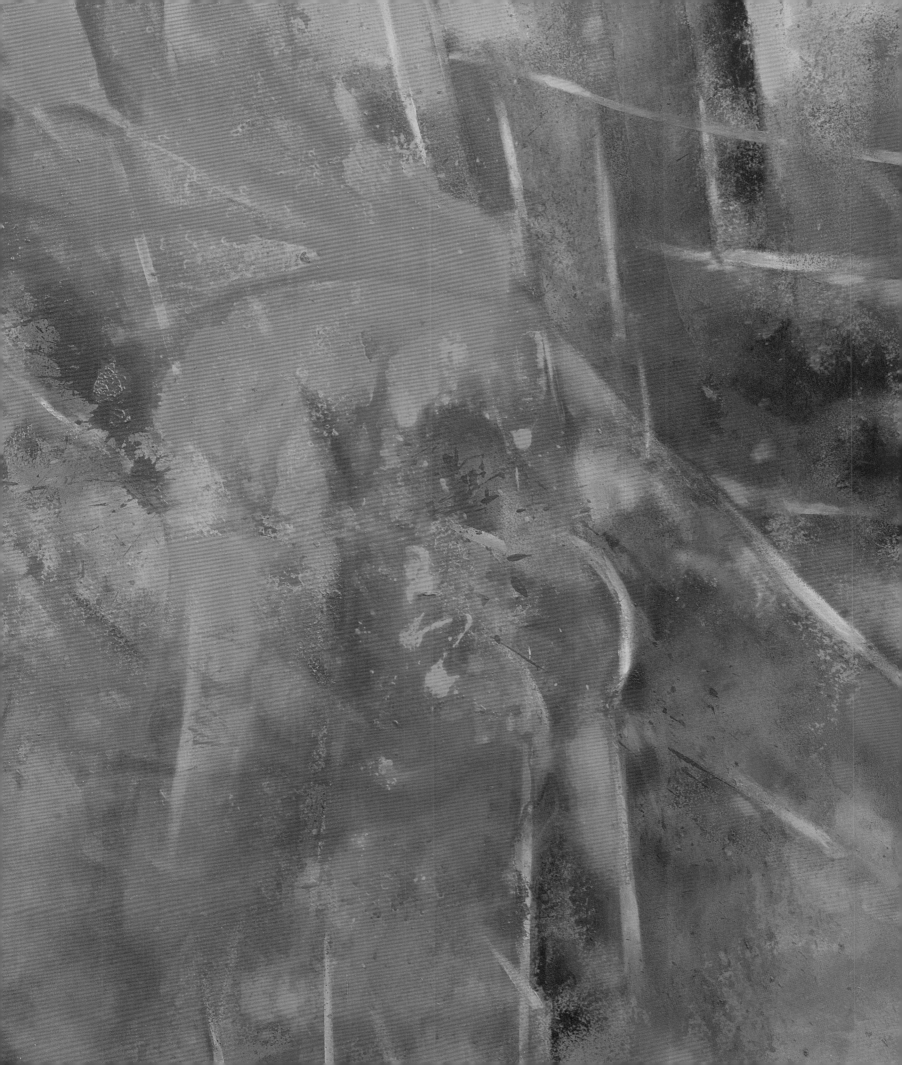

J. 11 (Ursus), 1989
Acrylic on canvas
162.6 × 223.5 cm
Yale Center for British Art,
Given by the Friends of British Art at Yale, 1989–90

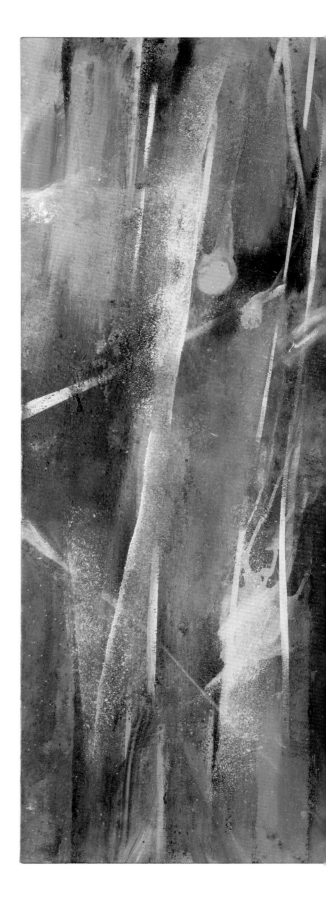

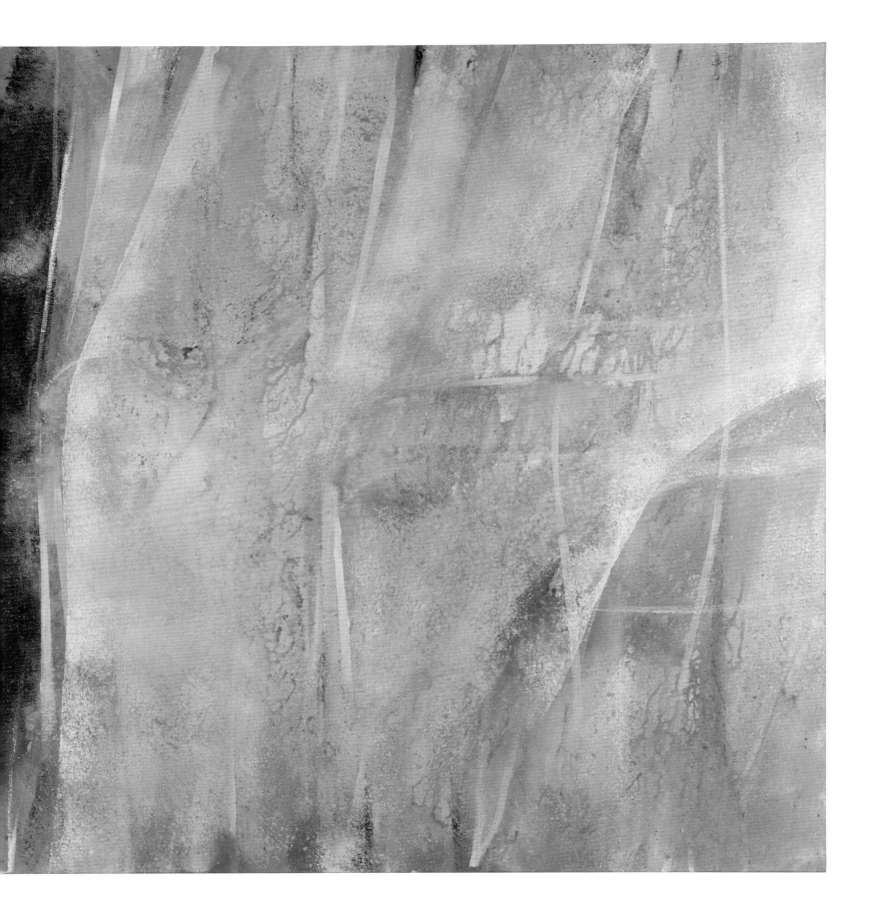

J. 21 (Bibemus), 1990
Acrylic on canvas
162.5 × 223.5 cm
John Golding Artistic Trust

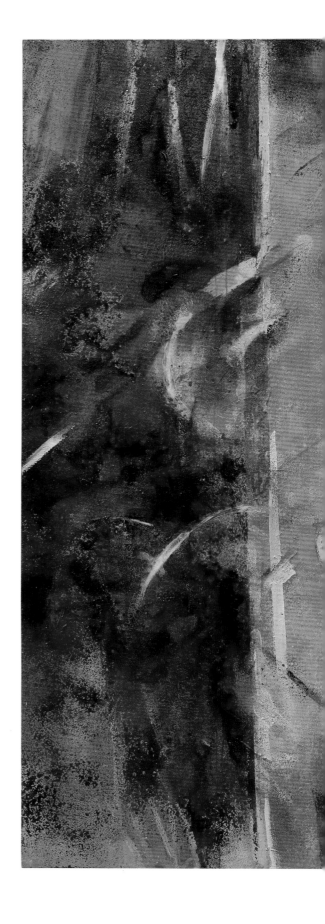

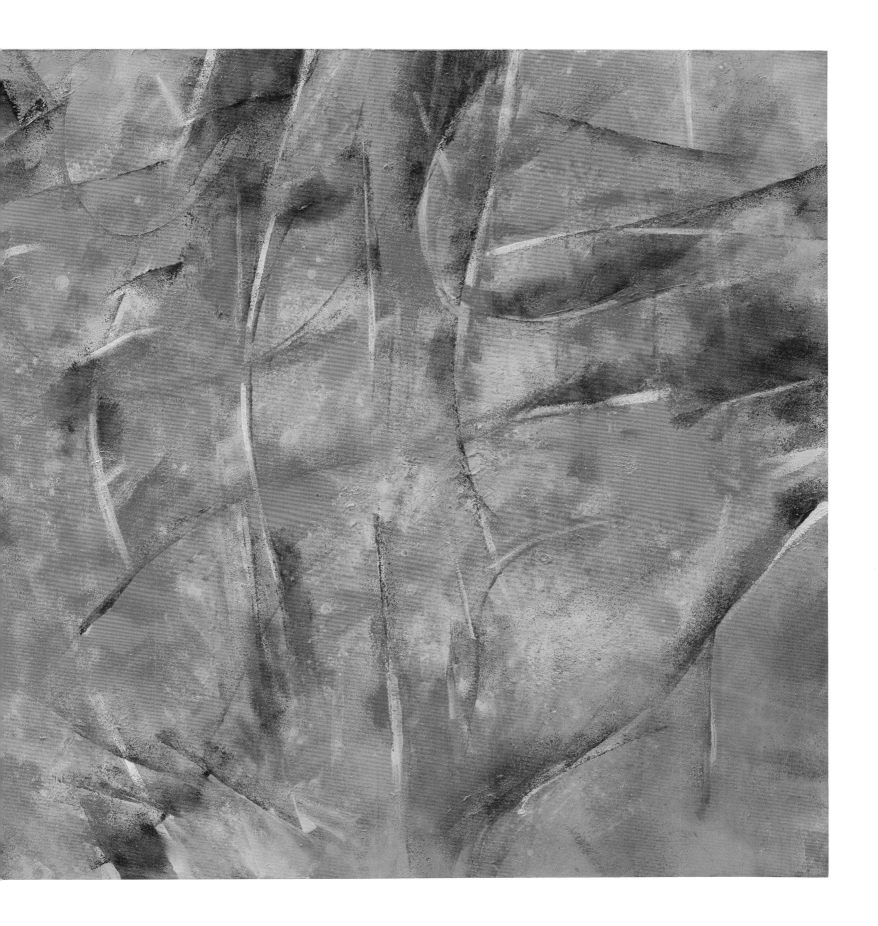

J. 16 (Zephyr), 1990
Acrylic on canvas
162.6 × 223.5 cm
Yale Center for British Art, Gift of the John Golding Artistic Trust

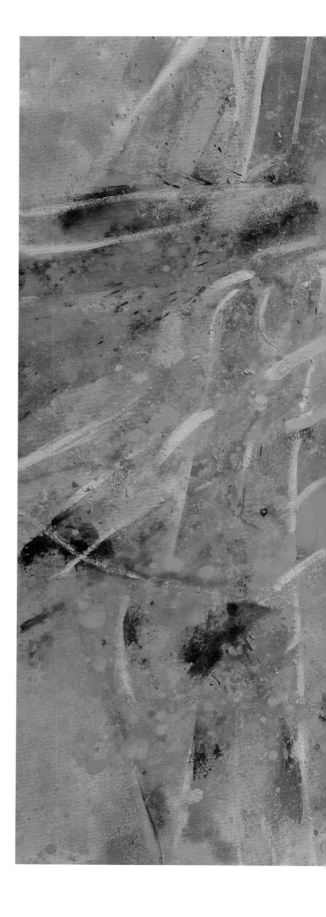

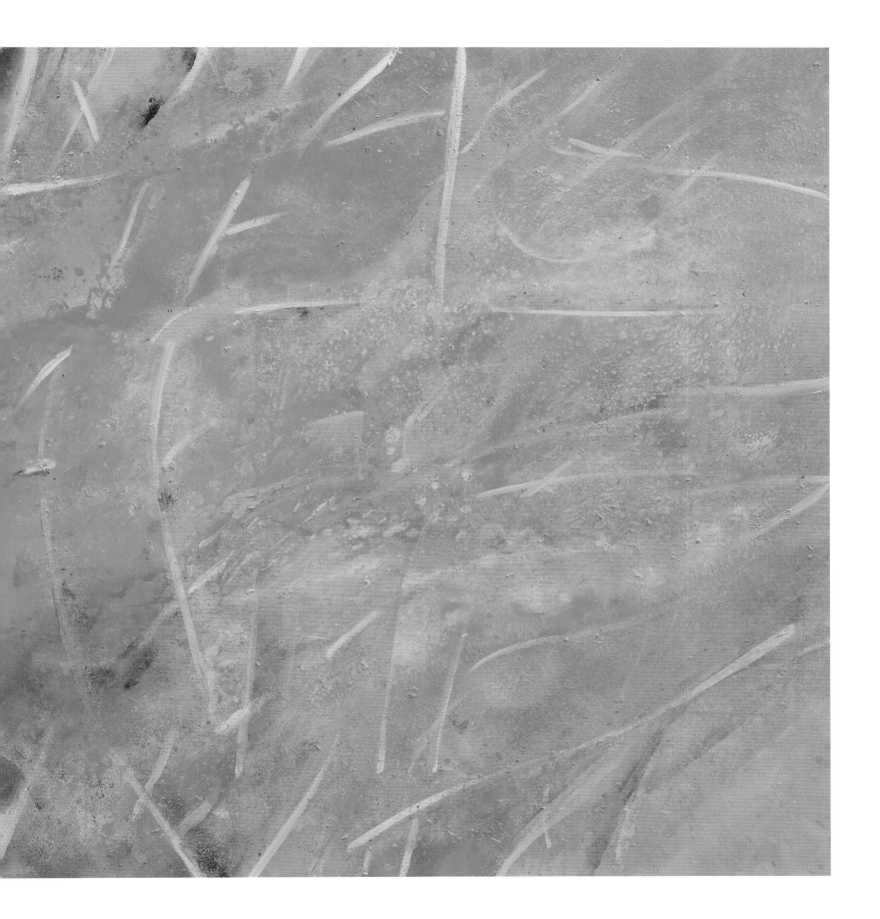

J. 22 (Sentinel), 1991
Acrylic on canvas
162.5 × 223.5 cm
John Golding Artistic Trust

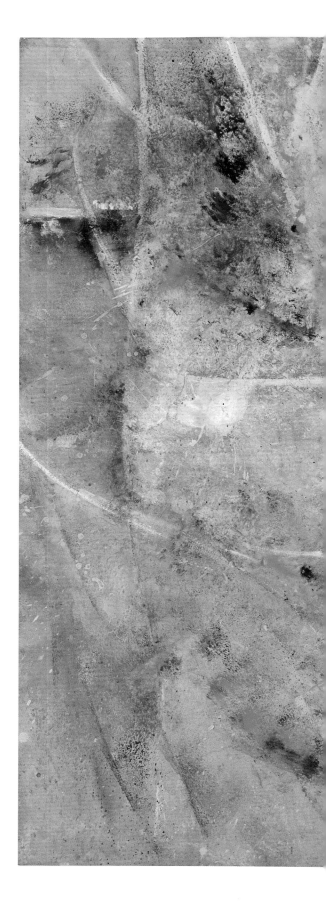

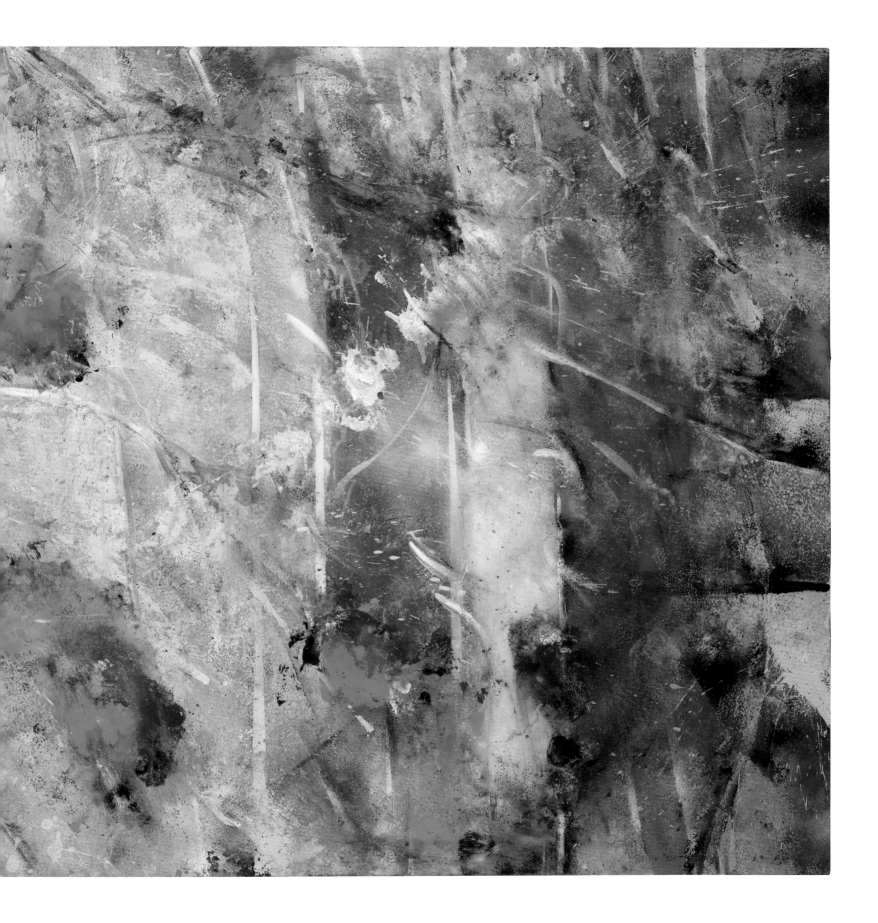

J. 15 (Ascension), 1991
Acrylic on canvas
167.6 × 228.6 cm
Private Collection

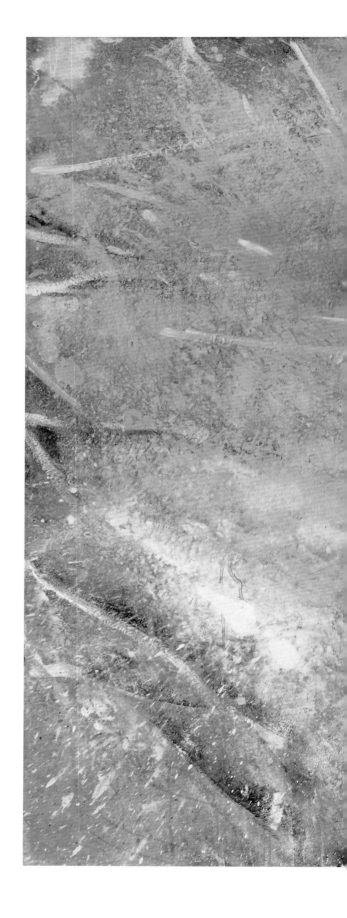

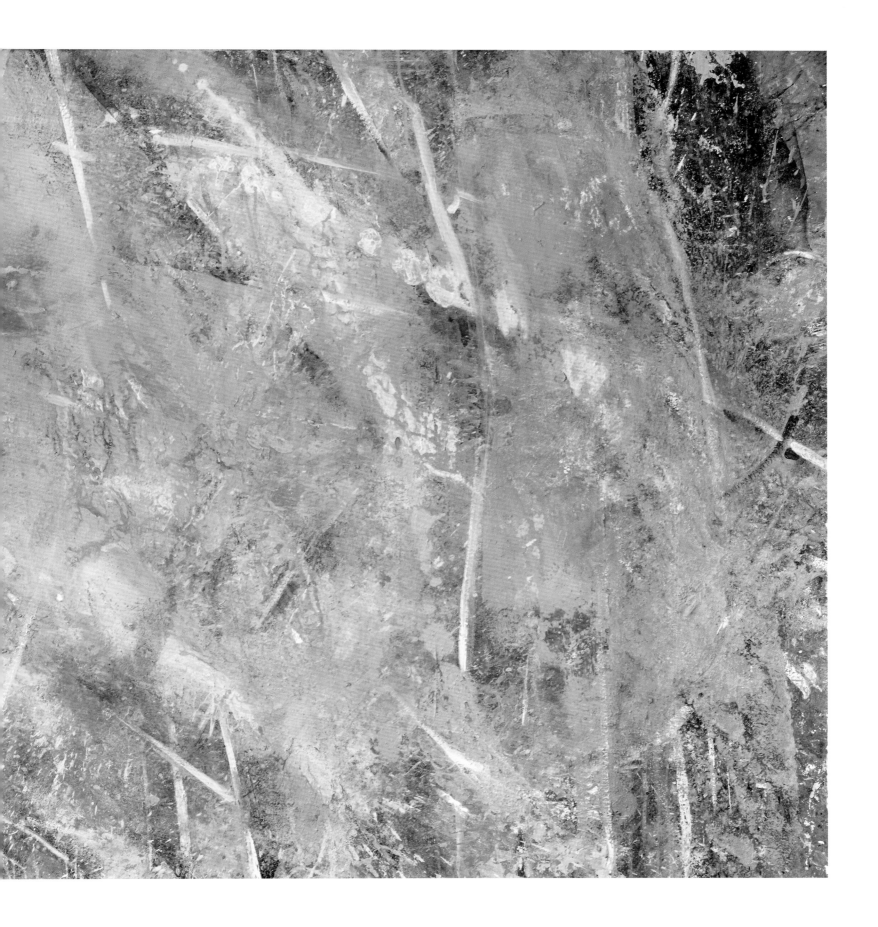

K. 4 (Mappa Mundi), 1992
Acrylic on canvas
165.1 × 233.7 cm
John Golding Artistic Trust

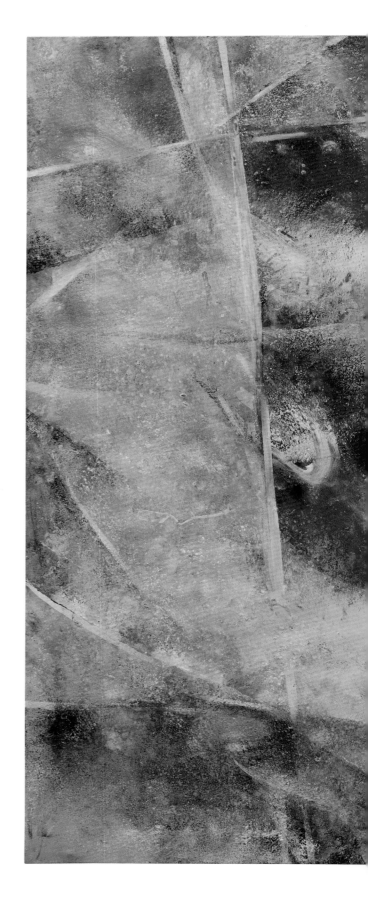

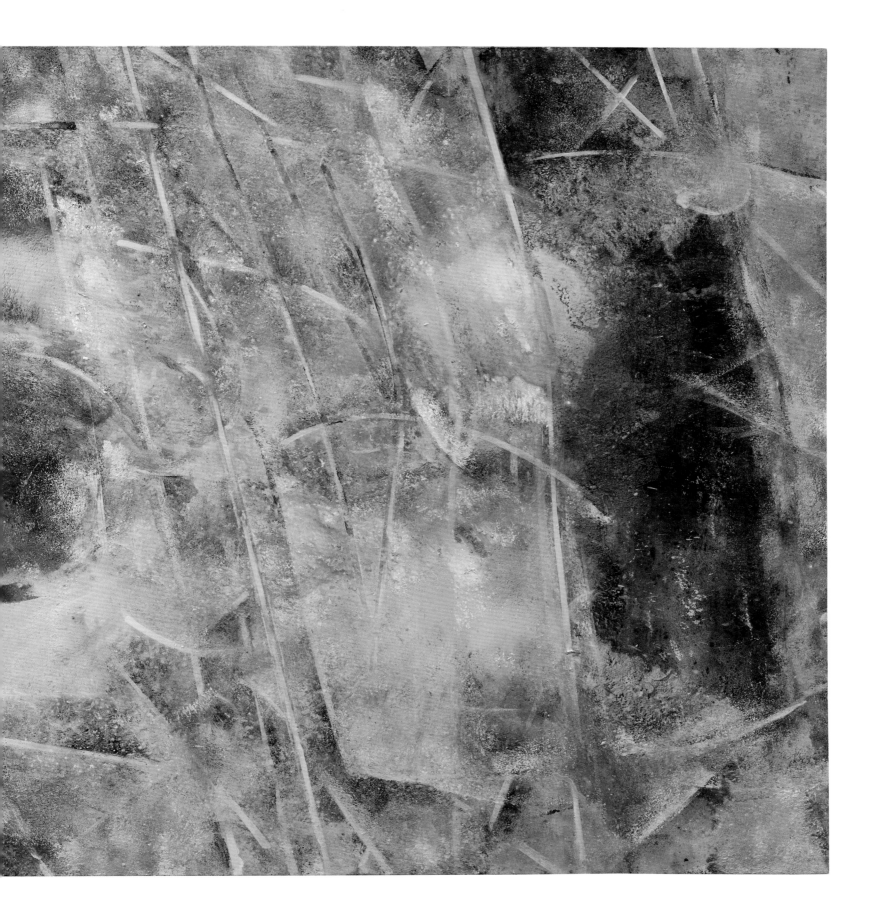

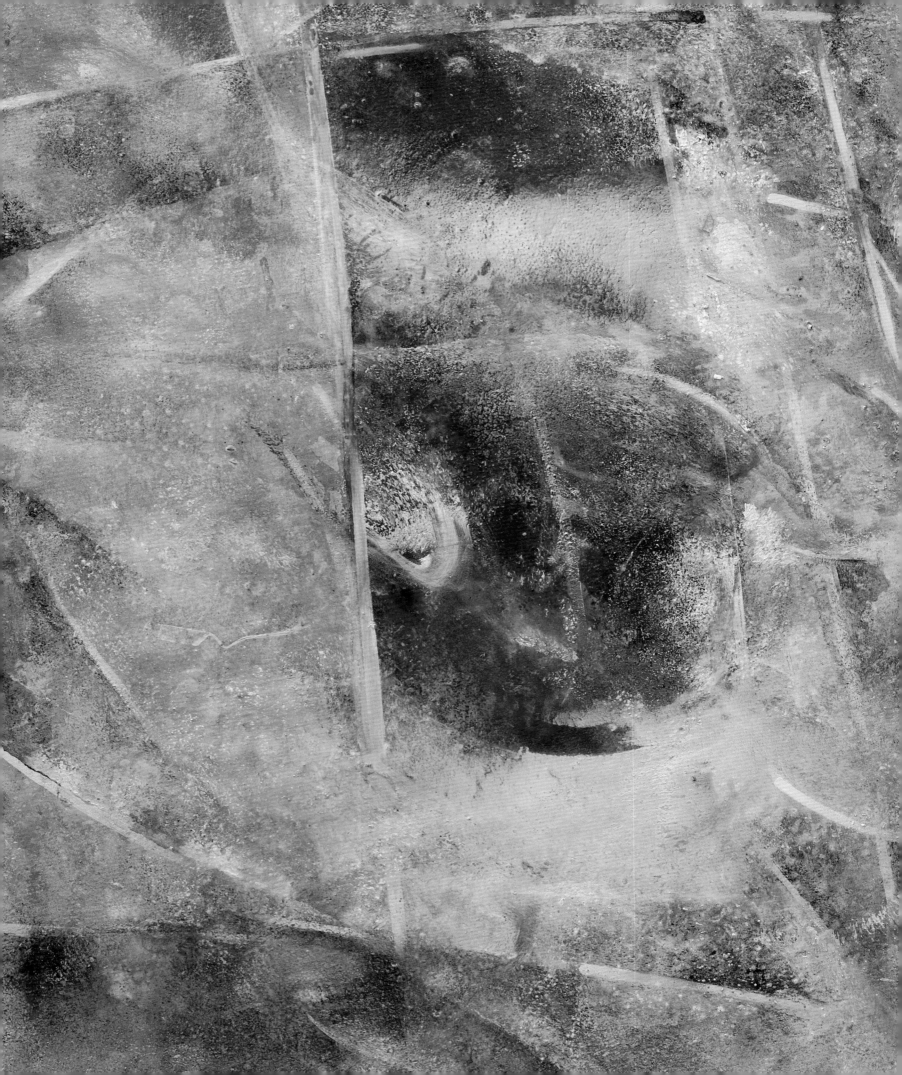

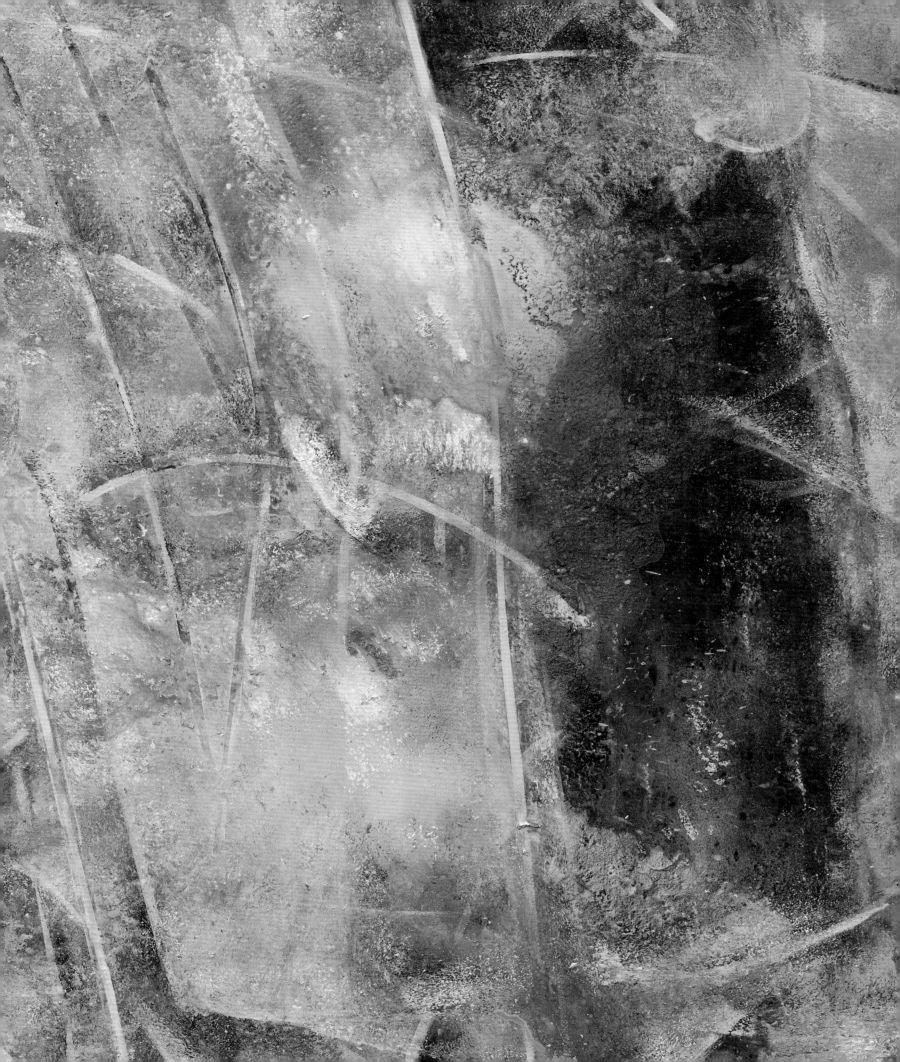

Arco Iris, 1992
Acrylic on canvas
163 × 224 cm
British Academy

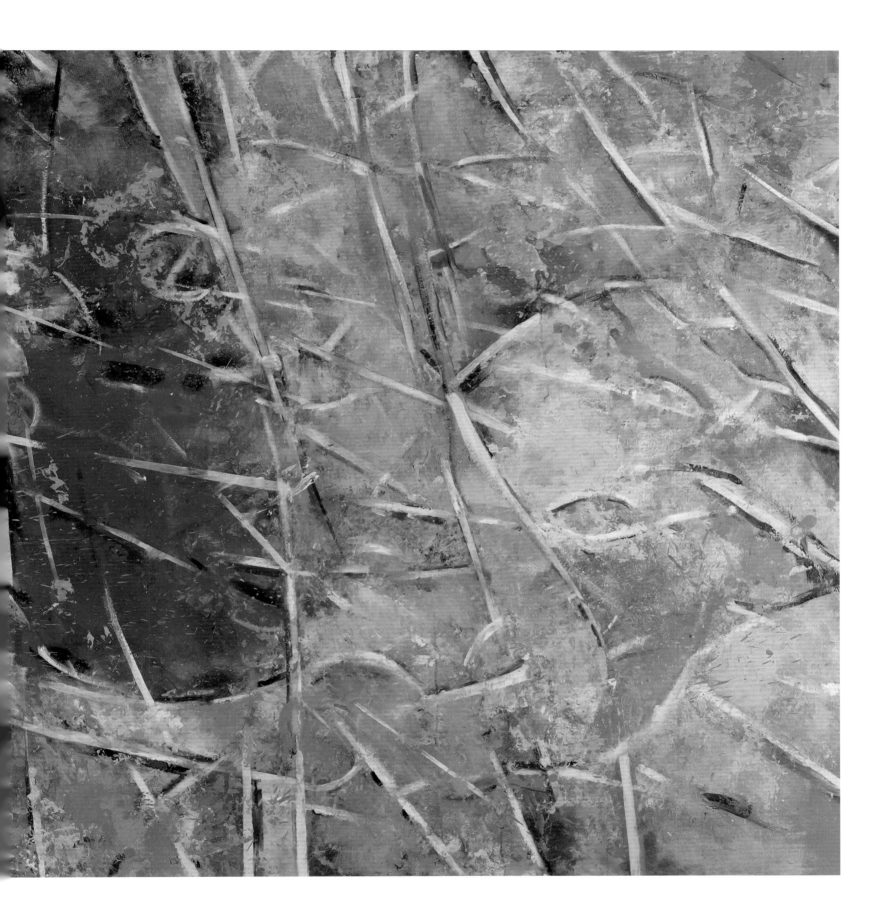

Memento Mori, 1993
Acrylic on canvas
141 × 188 cm
National Gallery of Australia, Canberra, Purchased 1994

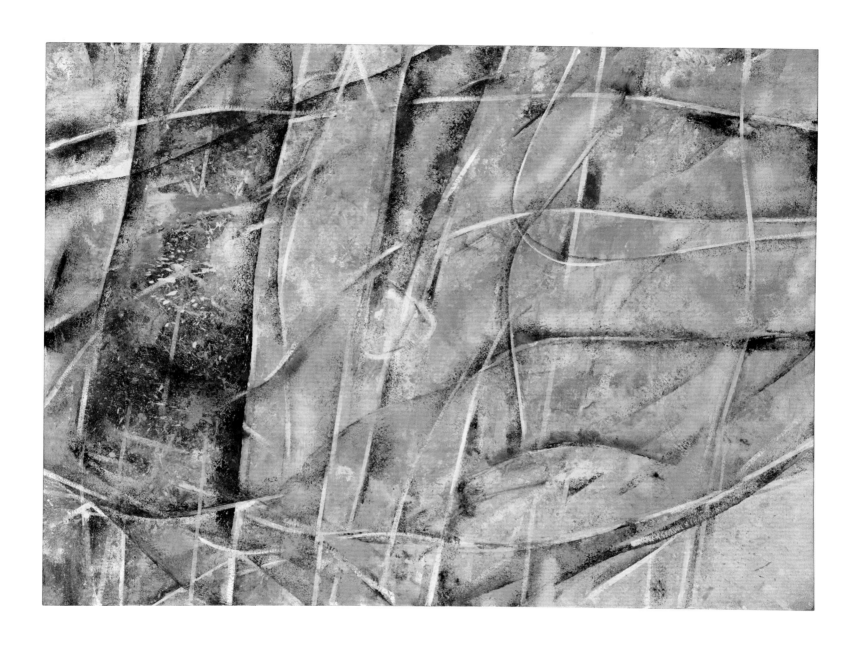

L. 1 (Mirage), 1998–2000
Acrylic on canvas
162.3 × 223.5 cm
John Golding Artistic Trust

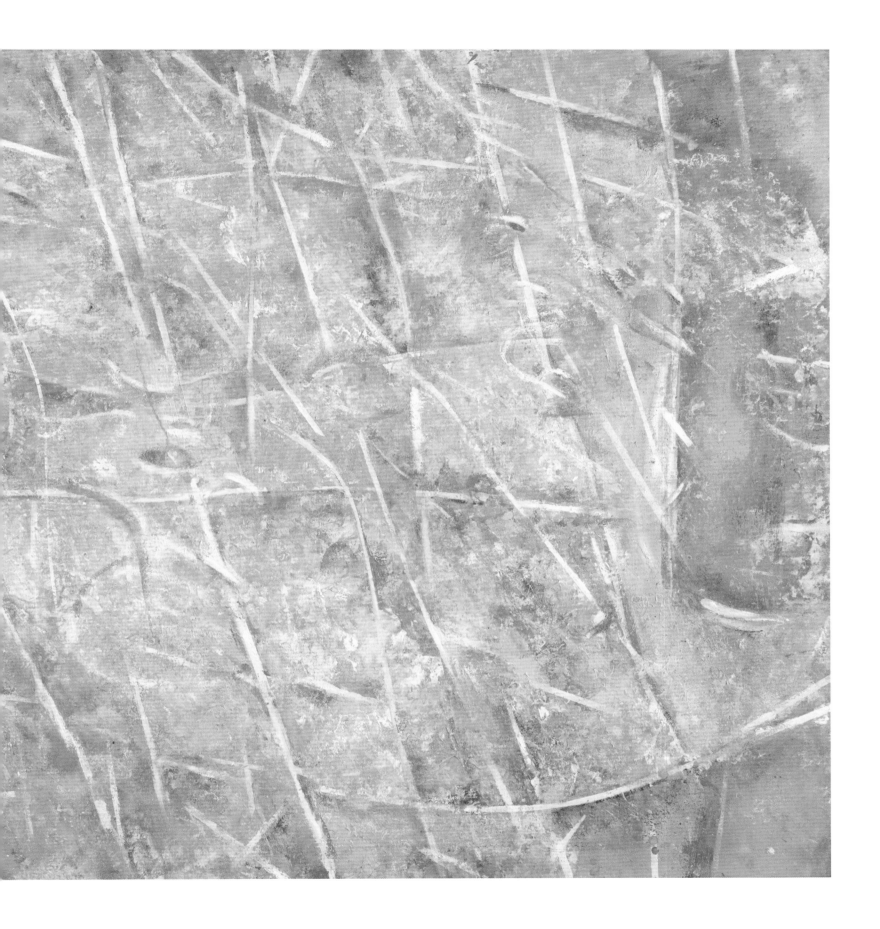

L. 5 (Galaxy), 2002
Acrylic on canvas
203 × 145 cm
John Golding Artistic Trust

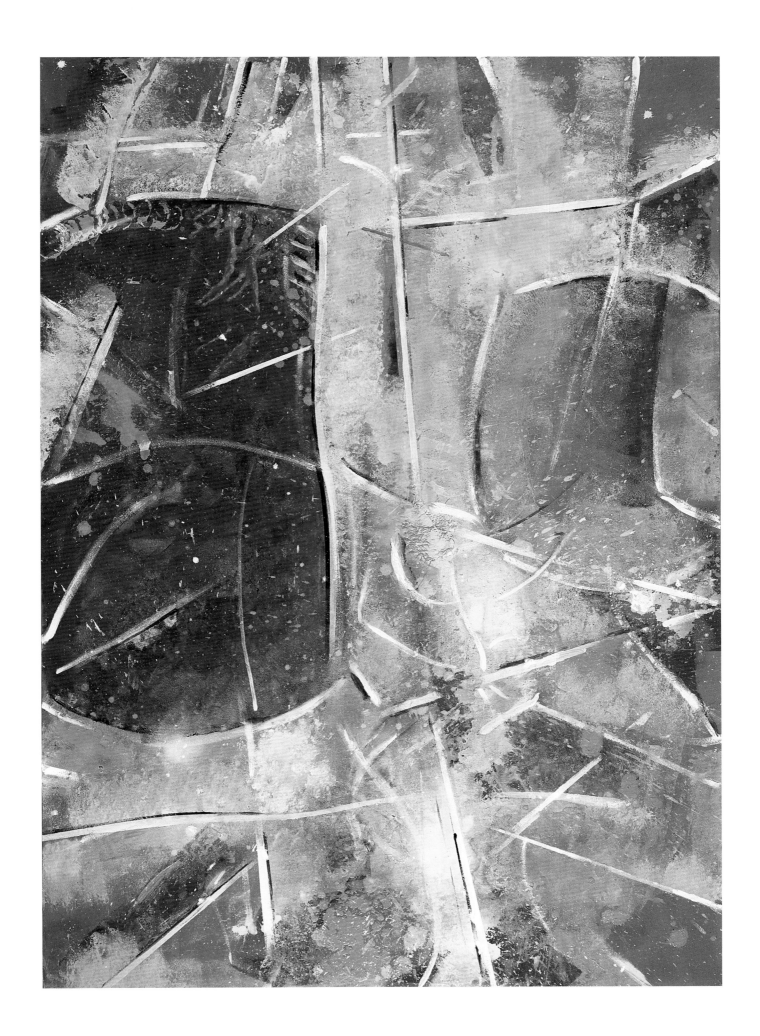

John Golding, American Art and a Personal View

David Anfam

This essay seeks to begin taking the measure of John Golding's thoughts on American artists such as Arshile Gorky, Barnett Newman, Jackson Pollock, Mark Rothko and Clyfford Still – all of them dear to my own heart. I append to its title the phrase 'a personal view' – and there is a certain reasoning to the informal voice. John was never, I feel, a system-builder. Still less, did he wear 'theory' like an exoskeleton, as it is *de rigueur* in certain circles today. Rather, John's insights often struck me as being the more powerful for their seemingly impromptu nature, as if they sprang, conversation-like, from a direct dialogue between himself and the artists in question.[1] It was his force of personality that, to my mind, lent penetrating gravity to his aesthetic judgements, and I find it impossible to separate my view of John as a thinker from that of him as a person. Between first hearing John lecture, over forty years ago, to visiting him at home on more than one occasion during 2010–11, shortly before his death, he figured at crucial moments in my life and career. When the following year I published a book on Clyfford Still and his newly formed museum in Denver, it was to John that I dedicated its text.[2] In hindsight, I am only pained that he did not live to see either the museum or the book.

The class of 1973 at the Courtauld did not, I think, know very much about John beyond his pedagogical identity. What little we, or at least I, did know came from the striking double portrait that RB Kitaj painted of John and his partner, the historian James Joll. [Fig.12] Probably I spotted a reproduction of it in *Studio International* or somewhere similar. Among other factors, the painting evokes an idiosyncratic and exotic figure, almost as though John were an emissary from distant shores, albeit with a touch of Carnaby Street about him. There is a lesson here. During the decades of the 1950s and 60s, modern American art had few vocal proponents in Britain. To be sure, when the Museum of Modern Art travelled *The New American Painting* to the Tate in 1959 it had a seismic effect

overall, yet it was not altogether a long-lasting one; a British school of Pop art soon rivalled it, not to mention further subsequent trends remote from Abstract Expressionism. Thus, it is probably fair to say that David Sylvester and Bryan Robertson were the two lone significant spokesmen for Abstract Expressionism in the UK throughout this period – Lawrence Alloway having moved to New York in 1961. That is, except for John. Having been brought up in Mexico, studied in Toronto and extended his research in New York and London, John had a natural head start when it came to Americanism (to use the word in its non-political meaning). At a stage when even the Courtauld's scholarly horizons rarely strayed beyond Europe (if understandably so at that date), John – who seemed outlandishly different to, say, the very English-born-and-bred teachers then, such as Peter Kidson, John Newman or Alan Bowness – struck me as an avatar of everything that I wanted to discover about art on the other side of the Atlantic.

In 1976 when I had completed the BA degree and was casting about for a subject for my PhD, I was stymied in pursuing Rothko (my first scholarly love) because the notorious 'Rothko case' (a long-running legal battle involving his heirs against the Marlborough Gallery) and its messy aftermath meant that the oeuvre in the estate remained inaccessible. So I asked my supervisor what I should do. Outright John replied, in quintessentially terse though challenging fashion, 'Clyfford Still'. Was he aware, I wonder, that Still would be the toughest of nuts to crack? Be that as it may, three years later – after doing a year's research in the United States – I had a routine meeting with John and was again surprised by his sudden apparent diktat: 'You've got to go back to New York.' When I complained that it wasn't long since I'd been there and that funds were, well, running low, he simply replied that Still was having a huge exhibition at the

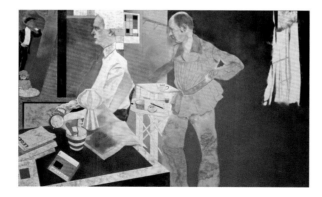

Fig.12
RB Kitaj
From London (James Joll and John Golding), 1975–76
Oil on canvas
152.4 × 243.8 cm
Private Collection

Metropolitan. The result? In December that year I met the notoriously elusive, irascible artist in person, a mere six months before his death. The point to grasp is that it took an astonishingly keen intellect for someone in the UK then to discern Still's 'underground' importance[3] – obscured even further by his intransigence and retreat from the art world. All the while, too, there was a strange, albeit faint, play of coincidences to our relationship, the more distinctive for it being on an everyday plane. For instance, by sheer chance, John happened to be at the National Gallery of Art in Washington, DC, preparing and delivering the AW Mellon Lectures in 1997, when I was there concluding the Rothko catalogue raisonné. The first time, in 1977, that I went to MoMA to visit William Rubin's assistant for scholarly guidance and referrals, as I waited in the reception area a door opened and out walked the two Johns: Elderfield and Golding. Likewise, over a much longer timespan, I remembered the happenstance that John was born the same year as my father, 1929. And when John died in 2012 it shook me to realise, eventually, that – as with Rothko and my father – it was scarcely due to natural causes, but to melancholia. My father even shared the same first name with John that evidently neither person much cared for, Harold.[4]

This reminds me of our first encounter in September 1973.[5] John was doing a lecture series at the Courtauld on Picasso. His speaking style was inimitable and charismatic. Some might say it evinced not a little degree of camp. If so, it was also riveting in its intensity and sureness. Most of all, you could not miss how John – notwithstanding the steely rigour of his learning – seemed on some subterranean level to empathise with the early Picasso (not to mention a slight

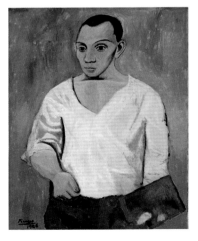

Fig.13
Pablo Picasso
Self-portrait, 1906
Oil on canvas
91.9 × 73.3 cm
Philadelphia Museum of Art

yet haunting similarity about their physiognomies). [Fig.13] However, the overriding relevance to my theme is that it was John's profound understanding of the Spaniard's achievement that positioned him well to address Abstract Expressionism. For if one had to mention a single artist who exerted a vast sway over Ab Ex (as I always call it for short), it would of course be Picasso. Pollock's remark, 'Just when you think you've found something new, that son of a bitch Picasso has got there first' (or words to that effect, since his quip comes to us second-hand, not verbatim[6]), spoke for most of his colleagues in New York. Put another way, Picasso helped pave John's royal road to Ab Ex.

A fortiori, it is noteworthy that the earliest of the Abstract Expressionists whom John esteemed was Gorky. Several points obtain. One is that John's purview of American art was very selective, reflecting not any academic lip service to chronology or comprehensiveness but, instead, quite simply his own tastes. Consider: nothing of the panoply of American modernism before Ab Ex; no Franz Kline, no Hans Hofmann and, perhaps most amazingly, no Willem de Kooning nor anything of David Smith (John's book on Umberto Boccioni confirms that he was as much at ease with sculpture as he was with painting[7]). If he didn't like or wish to explore it, it didn't figure in John's sights, or so it seems. Notice also the roster of names chosen for his book, *Paths to the Absolute*, published in 2000.[8] Four Americans counter three Europeans, a sign of the growing valency that he accorded the former. Of the Americans, only Newman stands apart in never having had a creative struggle or *agon* with Picasso. By comparison, John had already reckoned with Gorky.

In 1976 John took us students on a coach trip. The purpose? To visit a telling selection of Gorky's works at the Southampton City Art Gallery (those were the days when an institution of this rank outside of London could host such a show). John's passion for the Armenian-born émigré was evident outright and he would continue it in a masterful essay for Gorky's larger survey at the Whitechapel Art Gallery in 1990. As with much of his writing, John eschewed jargon, while making the most insightful observations in a deceptively straightforward manner. Yet it is hard to put one's finger on exactly where the brilliance lies, as though the whole exceeds the sum of the parts. This characteristic reminds me of another British writer whom I have long held in the highest regard, the literary scholar Frank Kermode.[9] It should suffice to say that John's central *aperçu* about Gorky speaks volumes. In a nutshell, the thesis was

that when Gorky finally discovered himself after years of self-imposed artistic apprenticeship to Picasso and other European masters, was it as a colourist or as a draughtsman? As he expressed it: 'In canvases of 1944 such as *One Year the Milkweed* line and colour are confounded to the extent that in some areas Gorky appears to be drawing over colour while in others he draws with it […] In other paintings line and colour now go their separate ways, although the dialogue between them remains active'.[10] I cannot imagine a more succinct, trenchant assessment of the fertile paradox at the crux of Gorky's strategies in landmark compositions of the mid-1940s such as *Water of the Flowery Mill* (1944). [Fig.14] They are the apotheosis of a born draughtsman seduced by the splendours of colour – and the more compelling for the two polarities being held in definitive irresolution, as though Gorky himself were unsure of his ultimate identity. The mix of hints of the existential (after a trauma-laden childhood in Armenia, Gorky's emigration to the United States left him feeling permanently uprooted[11]) with the formal (delineation versus painterliness) impressed me as a consistent tenet of John's critical methods.

John's take on Pollock in *Paths to the Absolute* holds another key to his standpoint. In a single sentence he captured the essence of the dialectic that drove Pollock and certain other Abstract Expressionists. Namely, that Pollock's art and sensibility pivoted around 'the dichotomy between the search for self and the longing to identify with an absolute'.[12] I strongly suspect that the progression of John's own art followed a similar path. In other words, it evolved from a vision of the human body to an absorption in sheer chroma. This

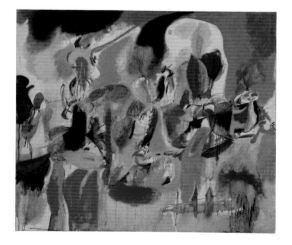

Fig.14
Arshile Gorky
Water of the Flowery Mill, 1944
Oil on canvas
107.3 × 123.8 cm
The Metropolitan Museum of Art,
New York, Gift of the George A.
Hearn Fund

perception enabled him to see the tug of war between pure form and experiential or symbolic dimensions that abounds in Abstract Expressionism. Simultaneously, it also explains John's aforementioned disregard for such movers and shakers of Ab Ex as Hofmann, Kline and De Kooning. Simply put, all three were indifferent or averse to the absolute (and, besides, Hofmann was the least existentially minded compared to any of his colleagues). By this reckoning, Ad Reinhardt presents a special case and I still wonder sometimes why this gadfly and maverick didn't feature on John's pictorial horizons. Probably it was due to how Reinhardt's entire project, geared to the absolute as it undoubtedly was, nevertheless aimed to kill colour and light in its pursuit of an eschatological, quasi-mystical darkness into which his erstwhile geometric abstractions melted. My guess is that John felt that with Reinhardt metaphysics had got the upper hand of pictorial mechanics. Be that as it may, the crux of the matter is that nothing meant more to John in his own practice and elsewhere than the factors of colour and light.

Speaking as a painter also enabled John to discern technical angles that eluded others. Again, to cite merely one signal instance: critics and academics such as Michael Fried, remarkable thinkers though they are, have expended reams of prose seeking to explicate those anomalous, troublesome Pollock paintings from his 'poured' period of 1947–50, in which the artist excised segments from the pictures' integument to create a kind of shadowy figuration redivivus. [Fig.15] Complex and not always plausible theories that postulate a notion of 'opticality' and the phenomenological genesis of a space somehow addressed 'to eyesight alone' – ideas sprung from a basis of Greenbergian formalist orthodoxy – attend what these commentators have written.[13] In

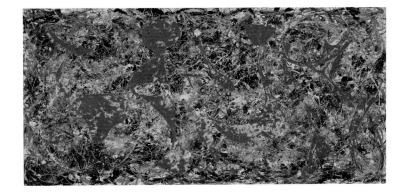

Fig.15
Jackson Pollock
Number 7: Out of the Web, 1949
Oil and enamel on Masonite
121.5 × 224 cm
Staatsgalerie Stuttgart

contrast, John was able to separate the wood from the trees. His argument was forthright. Namely, that Pollock had regarded these pieces as failed 'poured' paintings and so attempted, with mixed yet fascinating results, to bring them back from the brink by reintroducing a drastically pragmatic mode of drawing and a concomitant vestigial figuration into their erstwhile abstract, linear labyrinths. At stake, although John only hinted at this dimension, is a dialectic between self/representation/salvation and the absolute/abstraction/dissolution. John's reasoning makes sense where others have tied themselves in conceptual interpretative knots. Crucially, in his account of Pollock, John also reiterated the centrality of the body. To be sure, this is an obvious theme that many have pursued, reiterating one of the shibboleths of the New Art History. Nonetheless, John did it with a subtle and suggestive weave of ideas and perceptions that eludes easy summary.

On the other hand, what John found in both Newman and Rothko is obvious: consummate colourists. When he describes the classic Rothko image as 'liquid geometry' it is more than an impressionistic turn of phrase.[14] [Fig.11] Rather, it bespeaks Rothko's dual allegiance to both the firmness of Mondrian's rectilinear imagery (a compositional framework that incidentally, by a creative misprision, appealed to Rothko's emotional obsession with rigid confinement) and the dissolution, ergo potential freedom, associated with Surrealism's often metamorphic, lambent spaces. Understanding both the lineage of geometric abstraction in the twentieth century as well as its general antitype, that is, Surrealism and its recourse to automatism, lent John a special capacity to appreciate the contending polarities in Ab Ex. The subject of Rothko also leads to a completely different issue.

Evidently, John had a knack for both knowing artists and summing them up. To my pleasant surprise, he had once met Rothko when the artist's MoMA retrospective travelled to the Whitechapel in 1961. 'What was he like?' I asked. 'A big man and very sensuous, with heavy lips,' replied John. Odd and even wayward as this verdict may sound, it actually chimes with what those who knew Rothko closely tended to say,[15] and echoes the artist's own self-portrait of 1936 (replete with conspicuous red lips), a work that would have been unknown to John when we spoke. [Fig.16] In a comparable vein, John suggested that Rothko's paintings gave the impression that they were not there when they were not being looked at. Yet again, this ostensibly casual observation chimes with a

whole dramaturgy involving perception and reception in Rothko's crafty claims on the observer. As Rothko once observed: 'A picture lives by companionship, expanding and quickening in the eyes of the sensitive observer. It dies by the same token. It is therefore a risky and unfeeling act to send it out into the world. How often it must be permanently impaired by the eyes of the vulgar and the cruelty of the impotent who would extend their affliction universally.'[16]

Encapsulating Clyfford Still's creative trajectory, John concluded to me: 'Crude but shrewd.' This goes to the core of Still's unique combination (as both a man and a maker) of rawness and sophistication.[17] Likewise, as remarkable a teacher as John was, he remained – to his eternal credit – remote from the archetype of the academic art historian. Nor, significantly, so far as I am aware, did John ever choose to describe himself in such lofty but 'dead from the waist down' terms.[18] In this respect, it seems to me appallingly ironic that the Courtauld has long chosen to sidestep John's shining example in stressing the centrality of postwar American art and Abstract Expressionism to modern art history in general. Instead the institution puts the intellectual cart before the proverbial horse by trumpeting more modish contemporary fixations. Among them are post-colonialist critiques taught, of course, to the privileged scions of colonialism; obscurantist francophone theory; the catch-all rubric of 'subjectivity'; revanchism in the name of feminist psychoanalysis; Marxism lite; and the whole by-now tired crew of topics that are too often readymade substitutes for original and genuinely left-wing/radical critical strategies. My guess is that John would shudder at the Courtauld's current prospectuses and

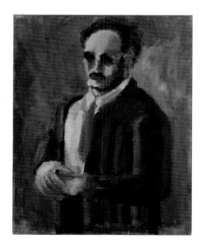

Fig.16
Mark Rothko
Self-portrait, 1936
Oil on canvas
81.9 × 65.4 cm
Private Collection

much of the direction of its teaching in the modern period. He certainly did so when we met, again in DC, in the early 1990s.[19]

However, to close on a more inspiring note, it was John who presciently saw the magnitude of Still. Not for nothing does the final page of *Paths to the Absolute* close with his memorable characterisation of this perennial outsider as 'the great unseen'.[20] Indeed, it may not be widely known – as John confided to me at a party two years later – that he originally wanted to put a Still painting on the book's cover and was only prevented from doing so by the copyright controlled by the artist's intransigent widow, Patricia. What enabled, *inter alia*, John's esteem for Still was that both shared certain aesthetic roots.

The salient passage from John's 1994 anthology of writings, *Visions of the Modern*, bears quoting in full:

> My first experience of contemporary art was of the Mexican Mural Movement. Orozco was my greatest source of inspiration, and I still believe he is one of the giants of the twentieth century, although his output was so incredibly uneven. One of the features of Orozco's art is the way in which his figures all seem to be in some way flayed; they wear their skeletons on the outside, like armour, although it is an armour that is useless, and he mostly seems to see humanity as doomed. I sometimes get the feeling that he painted out of hatred, a sensation that I also experience in front of another artist I enormously admire, Clyfford Still, although of course, in the end-products of both, the hatred is sublimated into very powerful art.[21]

Fig.17
Clyfford Still
PH-726, 1936
Oil on canvas
121.9 × 96.5 cm
Private Collection

An early, gruesome composition by Still should underline John's rationale. [Fig.17] Note the joint relevance of the Mexican muralists to Still's formative vision and John's; the manifold role of the body and its painterly excavation; and the pungent notion that the most powerful art may be born of sublimated hatred or anger.[22] Furthermore, who else in Britain between the late 1950s and the 1980s would even have had the Mexican muralists on their minds? Expansive in his learning and widely travelled, John had the breadth of experience that was necessary to take the measure of a polymath such as Still, whose library encompassed books on everything from ancient Greek philosophy and shipbuilding to those by Montaigne, John Ruskin, Norman Mailer, Gore Vidal, Pablo Neruda and Milovan Djilas's *Conversations with Stalin* (1962).

Turning to John's art, we can witness how it drew from Abstract Expressionism in general and Still in particular. The initial paintings of the 1950s, acknowledging the Mexican muralists, treat the (albeit unstated) Kristevan theme of *le sujet en procès* – that is, the self/body under trial and potentially metamorphic.[23] Their alarming abjection parallels that found in many fledgling images by the Abstract Expressionists, including Pollock, Still, Rothko, Gorky and David Smith. Then, by the early 1960s, these spectral figures start to deconstruct, while colour emerges as a redemptive force – which happens to be exactly what transpired in Rothko and especially Still's output during the 1940s. Finally, in the 1970s and after, light and intense hues gain a hard-won victory – with more than a glance towards Newman's precedent – in terms of the rectilinear-cum-horizontal ordonnance of the image, its field-like

amplitude and the corresponding use of much smaller marginal elements to enhance its overall impact. Superficially, the outcome may appear of a piece with the American formalist/Colour Field abstraction of the period succeeding Ab Ex – that of Jules Olitski or Kenneth Noland – but John's creations are in fact remote from the former in spirit, having a more subjective/figurative starting point and a human edginess.

John grasped the tenor of Still's art without coming in contact with more than a fraction of it, since the whole corpus remained out of sight during his active lifetime. From the very outset, Still's practice spanned what I believe constitute two concerns that were also key to John's interest: draughtsmanship and colourism. Even in a hitherto unknown and modest early piece by Still, such as the 1930 watercolour done somewhat in the style of Winslow Homer, both principles are already in action: witness the deftness of Still's brush in the unforgiving medium of watercolour and the delicacy of his palette. [Fig.18] With the Cézanne-like charcoal study of a skull done the following year, we are literally back to John's theme of the body that wears its 'skeleton on the outside', fixed in an atmosphere of doom (the little watercolour, *nota bene*, is also a symbolic landscape of death[24]). [Fig.19] Finally, with the coruscating abstractions of the 1940s and later, Still embedded the remnants of the figure, drawn with his indelible and savage contours and/or suggesting silhouettes rendered with chiaroscuro, into a saturated chromatic continuum that is at once fraught and exhilarating. A cartographic quality also pervades it, as though the vestigial subject were beheld from afar or above. The same applies to John's

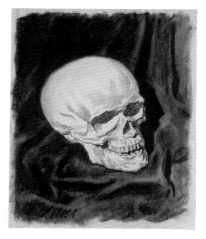

Fig.19
Clyfford Still
PD-102, 1931
Charcoal on paper
48.3 × 38.1 cm
Clyfford Still Museum, Denver

canvases of the 1970s: we seem to be looking as much down onto them (in terms of flat planes) as we look *into* them (in terms of chromatic depth). Also common to John's abstractions and Still's is the sense that their surfaces are being pulled or torn away to intimate half-seen depths below. Overall, therefore, at their best John's paintings and pastels trace a route analogous to Still's unfolding path.

John so narrowly missed being able to visit the collection whose mission is to secure the reputation of the artist whom he resolutely championed in the face of critical neglect, art-historical oversight and the subject's own retreat from view for many years. The Clyfford Still Museum in Denver holds a mind-boggling 95 percent or so of the artist's entire production, including almost 850 canvases, some 2,300 works on paper and much more besides. Yet what is certain is that John Golding's acumen and far-sightedness almost singlehandedly kept the flame of Ab Ex and its ongoing importance to contemporary art alive in Britain – through both his art history and pictorial practice – when other trends threatened to eclipse it.

Fig.20
Installation view at the Clyfford Still Museum with PH-23 (1944–45), PH-598 (1946), PH-272 (1950), PH-945 (1946), and PH-235 (1944), 2011.

1 To adopt Isaiah Berlin's famous dichotomy, John always struck me as a 'fox' rather than a 'hedgehog'.

2 Dean Sobel and David Anfam, *Clyfford Still: The Artist's Museum*, Skira Rizzoli, New York, 2012, pp.57–112.

3 Still himself believed that the worthy artist had to work 'underground', hidden from what he considered the malignant materialistic art world that operated in plain sight.

4 On an equally light note, my father's favourite cricket ground happened to be in the town where John was born: Hastings.

5 Even in 1972, when I applied for an undergraduate degree at University College, London, the person who interviewed me was the philosopher Richard Wollheim – in turn, a close friend of John's (though I had no idea at the time).

6 One raunchy variant is Steven Naifeh and Gregory White Smith, *Jackson Pollock: An American Saga*, Harper Perennial, New York, 1991, p.6: 'That fucking Picasso. He's done everything.'

7 John Golding, *Boccioni's Unique Forms of Continuity in Space*, Tate Gallery, London, 1985.

8 John Golding, *Paths to the Absolute: Mondrian, Malevich, Kandinsky, Pollock, Newman, Rothko and Still*, Thames & Hudson, London, 2000. Again, curiously enough, John received the Mitchell Prize for the History of Art in the award year immediately after I did.

9 There is a rarely noticed acknowledgement to Kermode's theories of eschatology in my first book. See *Abstract Expressionism*, Thames & Hudson, London and New York, 1990.

10 John Golding, 'Arshile Gorky: The Search for Self', *Arshile Gorky: 1904–1948*, exhibition catalogue, Fundacion Caja de Pensiones, Madrid and Whitechapel Art Gallery, London, 1990, pp.24–25.

11 Hence the title of John's essay.

12 Golding, *Paths to the Absolute*, op. cit., p.116.

13 See, for example, Michael Fried, 'Jackson Pollock', *Artforum*, vol.4, no.1, September 1965, pp.14–17.

14 Golding, *Paths to the Absolute*, op. cit., p.163.

15 The quality of sensuousness extended from Rothko as a person to his preoccupation with pictorial fullness. See David Anfam, *Mark Rothko: The Works on Canvas – Catalogue Raisonné*, National Gallery of Art, Washington, DC and Yale University Press, New Haven, 1998, p.11.

16 Mark Rothko, 'Ides of Art', *Tiger's Eye*, vol.1, no.2, December 1947, p.44.

17 Still's intellect was formidably wide-ranging, yet from first to last he remained an autodidact.

18 The reference is to the dessicated scholars Isaac Casaubon and his fictional counterpart Mr. Casaubon in George Eliot's *Middlemarch* (1871–72). See AD Nuttall, *Dead from the Waist Down: Scholars and Scholarship in Literature and the Popular Imagination*, Yale University Press, New Haven and London, 2011.

19 Although the exact year of this meeting escapes me, he replied with apparent horror: 'The atmosphere!'

20 Golding, *Paths to the Absolute*, op. cit., p.232.

21 John Golding, 'From Mexico to Venice. Postscript: Interview with Richard Wollheim', *Visions of the Modern*, University of California Press, Berkeley and Los Angeles, 1994, pp.338–39.

22 Still's library did indeed include this monograph, which he acquired in 1944: Justino Fernandez, *José Clement Orozco: Forma e Idea*, Libreria de Porrua Hermanos, Mexico, 1942.

23 Julia Kristeva, *Powers of Horror: An Essay on Abjection*, Leon S Roudiez (trans), Columbia University Press, New York, 1982, p.4.

24 Evident from the two dead animals, the Van Gogh-like preying crows and the blood-red sunset on the horizon.

The Eyes Have It: John Golding, Painter/Writer

Christopher Green

John Golding was one of a succession of fine twentieth-century writers on art based in Britain who were also painters: Walter Sickert, Roger Fry, Patrick Heron and Lawrence Gowing all come to mind. Like Golding, Fry was a writer whose art-critical and art-historical reputation has far outweighed his reputation as a painter, but who cared most about his painting. It is time to give the intensity, subtlety and the sheer visual beauty of Golding's painting the kind of attention his writing has attracted. Yet, one especially revealing way, I believe, into thinking about his work is via his writing, because as a painter his 'obsessions' (as he liked to call them) acted directly on his judgements as a critic-historian, and those judgements therefore bear directly on his decision-making in the studio. This essay will use his painting as a way into his writing and his writing as a way into his painting.[1]

My title, 'The Eyes Have It', is the title of John Golding's first review essay for the *New York Review of Books*, which appeared in March 1974, in the same issue as a major review of Aleksandr Solzhenitsyn's *Gulag Archipelago 1918–1956*.[2] That conjunction says just how far away we are from that moment, from this point in the twenty-first century. Golding's subject is a selection of writings by the critic Adrian Stokes, edited by his great friend, the philosopher Richard Wollheim. Stokes's writing on art could not be more different from Golding's. It is, Golding says of the later books, strangely diffuse, lacking focus, ahistorical, quirky, *revelatory* not *expository*. Golding the art historian could never be ahistorical, and his writing, in the most focused and lucid of ways, was always expository.

Yet, the review is positive, which says something else: Golding accepted and admired writers and, as we shall see, artists very different from himself, for Stokes was another painter/writer – and another friend – just a distinctly different painter/writer. Golding owned two of Stokes's paintings, both of which are characteristically diffuse yet acutely perceptive still-lives.[3] Stokes's painting

holds on visually, painted mark by painted mark, to his flickering experience of objects in space. [Fig.21] Golding had committed himself by 1974 to a kind of abstraction which can seem remote from any everyday world, but they were together in their commitment to painting that was about perceptual experiences, not literature – not words. Visual experience was where Golding's writing and his abstract painting originated, a need to engage with painting that, as he put it, could give him 'visual exhilaration'.[4] He confessed in the 1990s to falling under 'the legendary spell' of Marcel Duchamp's 'elegant' intelligence when he met him in New York in the 1950s, but freed himself from that spell because, for him, Duchamp was an artist who 'did not live his life with visual intensity and joy'.[5]

For Golding, visual pleasure was fundamental to his everyday as well as his painter and writer's life. In Duchamp he found a 'destructive humour', something that could never be said of anything he produced as a painter, but it should not be forgotten that Golding could write with a mischievous liking for the comic. Before dwelling on the serious substance of his writing and the give and take of its relationship with his painting, it is worth pausing to share the wicked pleasure he takes in one well-aimed jibe. It comes as a passing parenthesis in his review of the Juan Gris exhibition at the Whitechapel Art Gallery in 1992, and can serve to introduce his first serious piece of extended writing, a seminal study of Cubism. He observes that the unflattering shattered features of Gris's *Portrait of the Artist's Mother* (1912) bear 'a striking resemblance to the late Douglas Cooper'.[6] *Cubism: A History and an Analysis, 1907–1914* began as a doctoral dissertation at the Courtauld Institute under Cooper's supervision, and

Fig.21
Adrian Stokes
Still-Life, 1965
Oil on canvas
34.5 × 60.2 cm
Private Collection

nearly came to an end because Cooper – in a fit of infantile jealousy – tried to destroy it by failing it. The then director of the Courtauld, Anthony Blunt, rescued both the dissertation and the book. Golding, who had begun with Cooper as his friend and mentor, could hardly bear to hear his name.

The painter in the writer is already there to be seen in the Cubism book, but it was researched and submitted between 1953 and 1957, and when it was published in 1959 he had made no lasting decision as to the kind of artist he would be. His decisive commitment to abstract painting would not come till the mid-1960s. He was still then a figurative painter, and indeed some of his strongest figurative work comes just as that book came out. He spent the years between finishing his thesis and taking on his first job – as one of the first art historians at the Courtauld to specialise in twentieth-century art – making a real effort to develop as a painter, exhibiting in Mexico City in 1958 and with Leonora Carrington, Remedios Varo and Rufino Tamayo in Lima, Peru, in 1961.[7] Many of the canvases he showed in Mexico City were tough, unsentimental bird and animal paintings, and in 1959 he produced figure paintings which have a pitiless expressive force, which in the case of his *Desnudo Gris* (1959; p.37) dwells on vulnerability, and in the case of *'Ananias' (Homenaje a Orozco)* (1959) brings terror and suffering together in a bound body. [Fig.22]

In the 1990s, Golding was to reflect on his need to confront Cubism and grasp its importance, as a need to prepare himself for a full appreciation of the European, Latin and North American painting he had been excited by in Mexico and New York from his teenage years.[8] His *'Ananias' (Homenaje a Orozco)* pays

Fig.22
'Ananias' (Homenaje a Orozco), 1959
Oil on board
68.3 × 129.54 cm
John Golding Artistic Trust

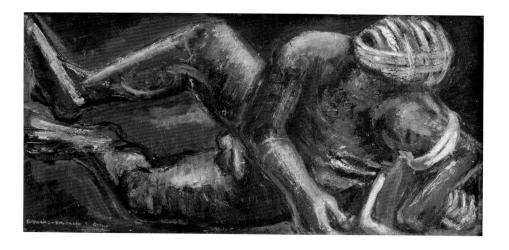

homage to the muralist José Clemente Orozco and his own Mexican beginnings. Jackson Pollock, whose drip paintings he had known before he started work on his doctorate, he would later insist was also 'haunted', as Golding would be all his painting life, by Orozco's cupola for the Hospicio Cabañas in Guadalajara.[9]

He was in no sense an 'Abstract Expressionist' in 1959; but he was also in no sense a painter working out of Cubism's sharply focused, reflective questioning of painting and sculpture's capacity to represent the world. He was a figure painter, committed, as was Orozco, to bodies as carriers of feeling, and to painting's expressive immediacy. And yet the core conviction carried by his study of Cubism is aligned with his sustained commitment, at this moment, to figurative painting. His book ends by regretting the association between abstraction and Cubism, identifying that as a major source of misunderstanding. Cubism, he would always stress, may have been anti-naturalist, but was above all 'an art of realism'.[10]

Neither the writer's satisfaction that the book might have given him, nor its success in establishing him as a leading young historian of twentieth-century art, diverted him from what would remain his primary commitment, painting. Just before he took the Courtauld job, he seems to have hesitated between his possible futures, as a painter and as an art historian, but in the end he took it on the condition that he could still have time to paint.

Golding's Cubism book is historical in its commitment to chronologies, but it is driven by critical not historical judgements, and his starting point is that of the painter he was: looking. Early in the book he makes a kind of mission statement, to show, by an 'examination of the paintings themselves', how, 'step by step', the painters 'evolved […] the means of expressing their new pictorial conception'.[11] As a writer on art, it would always be re-experiencing the passage of artists from work to work that would engage him. As a painter, he would himself continue to experience how it could feel to move out of the last painting into the next.

In the Cubism book, he is not concerned with modernity or the politics of culture as issues, and, of course, that opened him to criticism, especially in the 1980s and through the 1990s.[12] He respected the social art history that came out of the 1970s; he had, after all, supervised TJ Clark's doctoral dissertation, which became perhaps the foundational text of social art history in its late twentieth-century form.[13] The centre of his attention, however, is the painters and their

work, and if the emphasis is not on the historiography of Cubism, but on Golding the painter in Golding the writer, what matters is the way he repeatedly tries to think and feel himself into the place of the artist working as a Cubist.

It is telling that this comes across in ways particularly relevant to Golding the abstract painter, who will mature through the 1970s into the 90s, when he looks at the work of Braque. Alongside the making of works like *J. 21 (Bibemus)* (1990; pp.146–47) and *Arco Iris* (1992; pp.158–59), he fixed his attention again on Braque, whose folded spaces in the late Studio series (1949–56) [Fig.23] he took as cue for 'folding' light into his own canvases. In the 1990s, he curated two London exhibitions dedicated to Braque, not just knowledgeably but lovingly.[14] Though Daniel-Henry Kahnweiler and Guillaume Janneau anticipated the precedence Golding gave to Braque over Picasso in narrating Cubism's development, the way he retold the story in his Cubism book has an intensity of visual engagement that is still fresh.[15] Thus, Braque, for instance, does not merely flatten the violin and water jug in a key early cubist work, *Violon et cruche* (1909–10); he tries to convey 'the sensation of having walked around his subjects, of having seen or "felt" the spaces between them'.[16]

In one essential I cannot now agree with the way Golding implicitly separates mind from senses when he concludes that Cubism was 'conceptual and intellectual rather than physical and sensory'.[17] When, however, he writes on Braque's 'tactile space', he is already trying to get at how cubist paintings do not simply act as a stimulus for reflecting on the problem of representation, but could and can be 'felt' as experiences directly responsive to how we see and know things in space. He does not categorically separate the mind from the senses. Braque's 'concept' of the space in *Violon et cruche* is 'felt' visually, just as,

Fig.23
Georges Braque
Studio V, 1949-50
Oil on canvas
145 × 175 cm
Museum of Modern Art, New York

for Golding, Picasso's sculptural 'concepts' of bodies and things are.[18] Multiple perspectives – the fluctuation of relationships as they are experienced in space – were always, for Golding, central to cubist painting, not the canvas-bound flatness that his contemporary promoter of Cubism, William Rubin, insisted on, as a committed Greenbergian formalist.[19] To repeat: Cubism, for him, was fundamentally realist.

Cubism: A History and an Analysis was a mid-twentieth-century product of the epoch of definitive art histories. Several of Golding's teachers and colleagues at the Courtauld published in the genre.[20] Golding's *Cubism* is not a period history but an ism history; it follows John Rewald's histories of *Impressionism* and *Post-Impressionism* (1946 and 1956), and it fits in with them, but Golding's commitment to looking first and last, and the very nature of his topic, Cubism, as he thought about it, meant that he did not close the subject down, but led the way into an expanding field that could be occupied by very different critics and historians.[21] After all, Cubism was not, for him, in words he used later about Mondrian's response to it, about 'formal certainties': 'it was totally open-ended in its attempt to get to grips with the creation of a […] formal vocabulary by which to render perceived visual reality' without naturalism.[22]

For the painter he was, there could not have been a more ideal topic with which to begin writing seriously about art. Cubist paintings resist closed conclusions, and so did painting for him as an experience and an activity. His book brings out with acute sensitivity how one cubist work led unpredictably to another, how they were starting points, not definitive conclusions. Certainly, once he had made the move into abstract painting in the mid-1960s, he would have said very much the same about his own work, increasingly laying the stress on that word 'unpredictable'. And from the mid-1980s, his writing ceases to have the look of the definitive. He allows the pronoun 'I' to replace the Olympian objectivity of mid-twentieth-century art-historical writing – 'I wonder', 'in my view', 'I suspect', 'as far as I know'. Now and again, he is even 'baffled'.[23] He, John Golding, is always present in his painting, which from day to day perhaps sometimes left him 'baffled'. Now he is repeatedly present in his writing, however all-embracing his critical and historical judgements.

The remarkable series of articles he wrote for the *New York Review of Books* is where this shift to the first person takes place. That series does not properly begin with his 1974 piece on Adrian Stokes, but rather from the mid-to-late

1980s, when Golding's confidence and drive as an artist was giving his abstract painting real impetus. Those articles build first towards the anthology of essays *Visions of the Modern*, published in 1994, before leading to an exhilarating culmination in his AW Mellon Lectures, which were published in 2000 as *Paths to the Absolute*. His subject now, in *Paths to the Absolute*, is abstraction. The book, his last, compliments his first, devoted as it was to the new realism of Cubism. Yet, the fact is that already in the 1970s, before he left his teaching career as an art historian to teach as a painter at the Royal College of Art in 1981, he was lecturing on several of the artists and major themes of *Paths to the Absolute*: on, for instance, Malevich, Pollock and Rothko. Responding to and writing about those artists accompanied his work as an abstract painter almost all the way from the 1970s to the last acrylic on canvas by him that we know, which is dated 2002 (p.165). It is especially in the lectures put together in that book that Golding identifies the twentieth-century abstract painters who mattered most to him as a painter as well as a writer, though he would never lose his commitment to the modernist figurative painting of Matisse, Picasso and, as we have seen, Braque. So what about the painter in the writer when Golding the abstract painter's subject is abstract painting?

There is a common structure that the 'Paths to the Absolute' lectures keep to: it amounts to a strategy with an aim. The aim is to get into a position within which Golding can insert himself empathetically into his artist-subjects, as less often he does in the Cubism book. It is a painter's strategy. Social or contextual art-historical writing constructs spectators of a time and place – imagines a way into them, as Panofsky did into the medieval scholastic; theory-driven art-historical writing operates with some kind of meta-spectatorship, transcending historical specifics; Roger Fry imagined the ideal spectator as an intelligently rational, acutely observant painter, his ideal of himself.[24] Of the painters Golding writes about, several could not be more different from him as characters and as artists: Pollock and Clyfford Still are so very different. But Golding aims to insert himself empathetically into each one of them, just as he does into artists more superficially like him, Braque or Barnett Newman, which, as we shall see, is not to say that *his* situation as a working painter is irrelevant when he makes his empathetic moves as a writer.

He regularly homes in on what he calls *tabula rasa* paintings: paintings that set the artist back at zero: Mondrian's *Composition No.10* (1915), Malevich's *Black*

Square (1915), Newman's *Onement 1* (1948).[25] While he was lecturing on Malevich at the Courtauld in the 1970s, he was rumoured to be attempting his own *Black Square*, so strong was his wish to grasp what that *tabula rasa* experience could mean as a painting experience.[26] And indeed, when, in the mid-1960s, he himself had moved out of figuration, he had what might be called a long *tabula rasa* moment, making paintings where planes which at first can appear blank threaten to take over, sliding across severely reductive figurative vestiges, although, a longer, harder look reveals that those planes are actually far from blank.

It is as if, by moving into abstraction, he wants to join the community of real painters, as he understands them – painters who want to escape words altogether. His own eloquence went with voracious reading, but the painters he admired were, in his judgement, intellectually limited and, with one or two exceptions (above all Newman), handicapped as writers. Not to be able to write effectively about their art was, for Golding, a marginal issue; what mattered were the paintings, and abstract painting could challenge even gifted writers like him, could open a region beyond words. In his introduction to *Visions of the Modern*, he excused the omission of Mondrian on the grounds that his work was 'so formally perfect' and so totally embodied the concepts behind it that nothing else needed to be said.[27] Nonetheless, the very next year, he showed that a great deal could be said, by writing one of his most eloquent critical texts for the *New York Review of Books* in response to the great Mondrian retrospective in The Hague and the United States of the mid-1990s. That brief passage in *Visions of the Modern*, however, reveals that there was a moment when he was prepared to hold back before the wordless force of Mondrian's paintings. Could it be that when he passed through his own *tabula rasa* moment 30 years before, his move into abstraction went with a wish to widen the distance between his painting and his writing, so that his own intellectual and verbal gifts could not so easily intrude on work in the studio?

And yet, from the mid-1980s, it is increasingly Golding as a painter who gives impetus to Golding the writer, by empathetically inserting himself into the artists he writes about, including Mondrian. In the 'Paths to the Absolute' lectures, his strategy can be summed up thus: he begins each lecture by interweaving the briefest of biographical sketches with the much deeper and more wide-ranging construction of a cultural and visual environment within

which to imagine the artist. Only then does he project himself into the process of moving with the artist step-by-step from work to work. His cultural and visual shaping of environments applies his *musée imaginaire* of images, his curator's eye for speaking juxtapositions, and his reader's penetration of psychoanalytic and philosophical texts. Such texts only feature if they are demonstrably relevant: the Kabbalah and Judaism for Newman, Jung for Pollock, Nietzsche for both Rothko and Still, but a markedly different Nietzsche for each of them.[28]

Art historians now accept as potentially revelatory the practice of thinking back to earlier art with current or recent theory, or with theory their artist-subjects could not have known. Golding very rarely uses what we call theory unless there is evidence of an artist's awareness of it. Where there are exceptions to this, it is always because it helps build a credible space in which to imagine his artist-subject working; the way, for instance, in the case of Pollock, he uses the Jung of *Symbols of Transformation* (1967), taking account of the artist's Jungian analysis, and a treatise on American Indian sand painting that Pollock could not have known.[29] He was very much a painter of his generation in his intense dislike of theory where it took attention away from the work and the artist in their historical moment.[30]

By constructing cultural and visual spaces in which to imagine his artist-subjects, he is able to use his very special painter's insights to get into the experience of moving step-by-step from work to work, without losing touch with the fact that his artist-subjects have minds, memories and life experiences as well as hands and eyes. Most obviously, the painter is there to be seen in the accumulated experience behind Golding's writing on colour and the laying on of paint – the technical processes of painting.[31] His writing, however, is most revealing for his painting when it is engaged with the experiences painting opens up: not technique alone, but process and product taken together. There are two areas in which I see his writing and his painting coming together especially revealingly: his writing on space in painting, and what he called 'moving up and in'. They both show him, pushed by his own painting, going his own way, rather than ways already then signalled by the received wisdom of the 'literature'.

Golding's work as an abstract painter, to put it very simply, is always a matter of painting flat, fixing attention on what is happening on the surface, and

simultaneously filling the expanse of the surface with light and space. For him, as a painter, light and space could not be separated. It was in the one interview in which he dwelt at length on his own painting, the interview with Wollheim of 1989, that he spoke of the importance to his own work of Braque's folding of space. In doing so, his stress was not only on how this allowed more space to be compressed into his paintings, but how it allowed him to 'get more light' into them too. The 1980s had seen him do just this, as he explained, by progressively separating 'the flares or bands' which articulated 'the edges of the shapes', until, bent as if by unseen forces, they became the agents of a 'pleated', concertinaed space alive with light (pp.139, 140–43, for example).[32]

It is writing about another painter trying to find the words for painting – Frank Stella in his 1986 lectures 'Working Space' – that Golding is at his most eloquent on the shimmering, flaring space he worked for himself. He is reacting to another abstract painter's wished-for pictorial space.

> I believe there is an alternative to the baroque, swinging, muscular space that Stella proposes, a space that works on us more slowly but which can be just as all-enveloping. This is the space created by light – light that binds and separates objects, planes and shapes, that illuminates and spreads, and that can act upon our perceptions and our senses as powerfully if not physically as the visceral space in which Stella delights.[33]

Golding's engagement with space as a painter repeatedly gets into his writing on space from the mid-1980s on. The review of the Mondrian exhibition of the mid-1990s and the lecture it led to in *Paths to the Absolute*, is a case in point. At that moment, the way the Mondrian literature told us to look at Mondrian's mature abstract painting, especially in the 1930s, started from the assertion that it had so comprehensively annulled the figure/ground distinction, that its relationships were developed across the surface, as collisions and resolutions experienced temporally, not spatially. Yve-Alain Bois's long piece in the exhibition's catalogue developed a persuasive argument to say so.[34] But Golding is compelled to see space even in Mondrian's most built-up, most opaque whites of the turn of the 1920s and 30s; painting, for him, was always pre-eminently about light and space. Of the so-called classic Mondrians of 1929–30, he writes:

Mondrian's control of optical effects had […] become so sure and skilful that he could make each white shape appear to be personalised, just as each of his canvases seem to possess a personality of their own. Because of their variety, and because they read differently according to the size and placing of the planes they define, the whites also recede or advance in spatial interplay.[35]

The notion of 'moving up and in' is, for Golding, part and parcel of how pictorial space was actually experienced by painters, including himself, as they moved out of figuration into abstraction in the twentieth century. In the case of Mondrian, it takes him right up to the picture surface, as if to deny space, as it does in the case of Rothko and Still, and in a different all-enveloping sense, Pollock. Writing about Mondrian's windmill pictures of 1907–08, he brings out the way Mondrian comes right up close to the mills, and comments: 'One of the many ways into abstraction can involve a move up into the very breast of perceived reality'.[36] As when he sensed Braque moving round things, he projects into Mondrian's mobile relationship with what he paints. When he writes about Still's *September 1946* (1946), he has him 'moving up into his art', not his subject matter, and comments that Kandinsky might have added to 'veiling' and 'stripping bare' a third way into abstraction: 'moving up and in'.[37] In this instance, Golding's sensitivity to the physical actuality of a painter's distance from his subject, and, in abstract painting, from the painting which is being painted is, very obviously, a sensitivity developed from his lived experience as a painter.

Golding helps us turn from Mondrian, Still, Rothko and Pollock to his own painting, when he speaks of his personal move from figuration into abstraction in his interview with Wollheim. He speaks of moving up and into what had been his subject when the Cubism book was published and through the early 1960s, the body, so that the painting becomes a surrogate body. 'In one form or another,' he says, 'the body is still always there in my work.' It is 'what my paintings are about'.[38]

Confronted by the abstract paintings from the later 1970s through to the 90s, Golding's own word 'baffling' attaches itself easily to his claim. How can paintings about light and space be ultimately about the body? And how can they be when, with the sole exception of his very last painting, all have a horizontal landscape format? In the Wollheim interview, he accepts that their format

encourages landscape 'connotations', but this does not 'bother' him. He is not worried that others might find the elements – water, air, earth – in his paintings; this in no way weakens his strong feeling for them as bodily presences. How could this be so? We have an invitation to emulate his empathetic projections into Braque or Mondrian or Pollock in the studio, and attempt to imagine how he might have experienced 'moving up and in' as a process that opened up not just a space, but a body.

In this respect, the question of format is a diversion, but not the question of scale, and there are clues as to how, for him as a painter, scale related to his bodily experience of his work in the way he writes about it. He had his moment when he painted huge, loft-scale canvases (pp.72–73), but by the time he responded to Stella's 'Working Space' lectures, he had come to dismiss working on such an enormous scale. It deprived painting, he writes, 'of physical space in which to live'.[39] He is especially revealing on scale when he writes about Pollock. In the Pollock lecture in *Paths to the Absolute*, he makes a telling comparison between 'the most successful Pollocks' and the work of another painter he admired, Turner. Even 'a thumb-sized watercolour notation of a storm at sea by Turner', he writes can 'dwarf us', but not those Pollocks, because not only their rhythms, but their scale 'cause one to measure oneself up to them in such a way that one is always aware of the human scale and oneself as a human presence in relation to them'.[40] Body and paint surface are identified with one another. Golding speaks in the Wollheim interview of the opened-up bodies he painted in the early 1960s, just before his *tabula rasa* moment and move into abstraction, as terrifying because of the way light penetrates the body. 'In the later work,' he says, 'light falls on the body and explores the surface.'[41] The picture surface becomes a skin.

What then of the space opened up? Despite the 'terror' he says he felt when faced in his early 1960s work with the body 'penetrated', if we return to the work that took him out of figuration into abstraction, in fact what can be followed is a deepening wish, not merely to approach the surface of the body, but to reach into and beneath that surface, a wish that changes character but is not arrested. The early 1960s bodies first open up to reveal hidden chambers, then, more savagely worked, are literally broken into, their ribcages burst open (pp.41–49). The light that penetrates these bodies is a brutal force, one that could certainly have aroused 'terror' in the painter who released it.

In the first abstract paintings, there may be sometimes the hint of heads or even elegantly dismembered bodies, but the centred image goes and colour takes over (pp.51–57). More and more Golding is concerned with a skin of colour. That skin is layered, however, so that underlying colours seep into surface colours, and so that colour as light can seem both to spread across the surface and simultaneously to be emitted from beneath it, as if there is a mysterious, luminous interior. This conflict between colour and light flaring from the surface and colour and light emitted from beneath it, between the surface as skin and as opening into an interior, becomes stronger from the late 1970s on, as the forces become more turbulent, so that space close to and right up on the surface can indeed become, as we look, as much air and water as a skin (pp.92–107). If these are the surfaces of bodies, they are also spaces filled with forces which light them up, heat or cool them, pull them together or fling them apart, spaces for any viewer to move 'up and into'.

My response to the surfaces and spaces of Golding's later abstract work is my own. Like his writing, his abstract paintings do not pretend to be definitive. Their surfaces and spaces can be experienced in different ways, something of which he was well aware. For him, ultimately, his paintings were bodies. He felt them as such right through the experience of making them and then viewing them. But he did not demand that everyone view them as he did. The way he wrote art history was driven by a need to get inside each of the artists about whose work he felt compelled to write, to project empathetically into their moves from painting to painting. We can try to project with our own empathetic powers into how Golding's paintings of the later 1980s and 90s can be experienced as bodies, guided by his words. That is what Golding the writer tried to do when he wrote about the work of the artists he admired. I have to recognise, however, that as a painter confronted by the work of other painters, his chances of finding words that count – that do not run away with themselves – were far greater than mine.

The sheer visual exhilaration left us by John Golding's abstract work can have its effect without the need of words, yet will never exhaust them. One way into it may be, as I have argued here, the words he found for the work of the artists he admired, from Braque and Picasso to Mondrian and Pollock, but Golding the art historian does not lead the way to anything like a final statement about Golding the painter.

1 The difficulty in writing this essay is that it comes out of a personal relationship in which 'Dr. John Golding' of the Courtauld Institute notice-board became 'John'. There is something off-putting in the distance created by replacing 'John' with 'Golding', but if I am to write about John Golding as a critic, art historian and painter, some distance is needed, so here he will become 'Golding'. My relationship with John started when I was a student at the Courtauld, and developed when I became his colleague there. As an art historian, he was the most open and generous of teachers and colleagues to the extent that he rarely betrayed the conflict that we now know continued within him through the 1970s, between Golding the art historian and Golding the painter. By 1981, when he made his decisive move into painting, Golding the painter was beginning to have enough of a presence in the London art world for the move not to have come as a shock. David Anfam, in this publication, implies that John would have 'shuddered' at the emergence of what have been dubbed 'new art histories'. In the years leading up to the Mellon lectures and in the last decade of his life, I recall no evidence of this, though it was clear that he always put artists and their work first, and was quick to express his dislike of writing that was driven by theory. When he left the Courtauld in 1981, he ceased entirely giving lectures and seminars there, though he kept in contact with some of his former colleagues, including myself. Being a painter took over very completely, despite his curating activities and his regular reviews in the *New York Review of Books*. Yet, contrary to the opinion David Anfam expresses in this publication, my memory is that John retained a sympathetic interest in the Institute. I recall in particular the warmth of his welcome when I visited him with the present director, Deborah Swallow, towards the end of his life.

2 John Golding, 'The Eyes Have It', *New York Review of Books*, vol.21, no.4, 21 March 1974, pp.38–40.

3 These are both now in private collections, one in London, the other in Edinburgh.

4 He recalls interviewing him twice while researching Cubism in 'the mid-1950s'. John Golding, *Visions of the Modern*, Thames & Hudson, London and New York, 1994, p.9. His fascination with Duchamp led him to write what has become a 'classic' on Duchamp's *Large Glass*. John Golding, *Duchamp: The Bride Stripped Bare by her Bachelors, Even*, Penguin Books, London, 1973.

5 What he responded to in French art in the first two decades of the twentieth century was, he writes, its 'visual exhilaration and incandescence'. Golding, *Visions of the Modern, ibid.*, p.9.

6 John Golding, 'Living Still-life', *New York Review of Books*, vol.40, no.3, 28 January 1993, pp.27–29.

7 The exhibition *Pintura Mexicana Contemporanea de la Galería de Antonio Souza* was held at the Instituto de Arte Contemporaneo in Lima, Peru.

8 He writes that seeing the Cubism exhibition at the Musée national d'art moderne in Paris in 1953 convinced him that 'I could never fully appreciate much subsequent modern art, that had already come to mean so much to me, until I had come to terms with Cubism.' Golding, *Visions of the Modern, op.cit.*, p.8.

9 John Golding, 'Pollock and the Search for the Symbol', *Paths to the Absolute: Mondrian, Malevich, Kandinsky, Pollock, Newman, Rothko and Still*, Thames & Hudson, London, 2000, p.113.

10 'The fact that Cubism gave birth to so much abstract art may be one of the reasons why it has been so consistently misunderstood […] Cubism, it must be stressed again, was an art of realism'. John Golding, *Cubism: A History and an Analysis, 1907–1914* (1959), Faber & Faber, London, 1968, p.184.

11 Golding, *Cubism, ibid.*, p.17.

12 Criticisms were rarely direct, and are more often implicit in the alternative approaches to Cubism that emerged especially in publications of the 1990s. Important instances are: Patricia

Leighten, *Re-Ordering the Universe: Picasso and Anarchism*, Princeton University Press, Princeton, 1989; Mark Antliff, *Inventing Bergson: Cultural Politics and the Parisian Avant-Garde*, Princeton University Press, Princeton, 1993; David Cottington, *Cubism in the Shadow of War: The Avant-Garde and Politics in Paris 1905–1914*, Yale University Press, New Haven and London, 1998. For an analysis of the historiography of Cubism, see David Cottington, *Cubism and its histories*, Manchester University Press, Manchester and New York, 2004.

13 In the two books: TJ Clark, *Image of the People: Gustave Courbet and the 1848 Revolution* and *The Absolute Bourgeois: Artists and Politics in France, 1848–1851*, University of California Press, Berkeley, 1973.

14 *Braque: Still Lifes and Interiors* (South Bank Touring Exhibition), South Bank Centre, London, 1990; and *Braque: The Late Works*, Royal Academy of Arts, London, 1997.

15 Daniel-Henry Kahnweiler, *Der Weg zur Kubismus*, Delphin Verlag, Munich, 1920; Guillaume Janneau, *L'art cubiste. Théories et realisations. Étude critique*, Editions d'art Charles Moreau Paris, Paris, 1929.

16 Golding, *Cubism, op.cit.*, p.84.

17 Golding, *Cubism, op.cit.*, p.16.

18 For Golding on 'sculptural completeness' in the Picasso of 1909, see Golding, *Cubism, op.cit.*, pp.81–83.

19 Rubin is at his most Greenbergian on Cubism in his essay 'Cézannisme and the Beginnings of Cubism', in Rubin (ed), *Cézanne: The Late Work*, exhibition catalogue, Museum of Modern Art, New York, 1977.

20 One important manifestation of this was the Pelican History of Art series, one of whose earliest volumes was Anthony Blunt's *Art and Architecture in France 1500–1700*, which was published in 1953, the year Golding started work on his dissertation.

21 John Rewald, *History of Impressionism*, Museum of Modern Art, New York, 1946; *Post-Impressionism: From van Gogh to Gauguin*, Museum of Modern Art, New York, 1946.

22 Golding, *Paths to the Absolute, op.cit.*, p.20.

23 The ascendancy of the pronoun 'I' is already there in the first of his major succession of reviews in 1985, an article on Pierre Schneider's two volume *Matisse*. John Golding, 'The Golden Age', *New York Review of Books*, vol.32, no.1, 31 January 1985, pp.3–6.

24 For Panofsky, see Erwin Panofsky, *Gothic Architecture and Scholasticism*, Archabbey Press, Latrobe, PA, 1951.

25 John Golding, 'Mondrian and the architecture of the future'; 'Malevich and the ascent into ether'; 'Newman, Rothko, Still and the reductive image'; in Golding, *Paths to the Absolute, op.cit.*, pp.26, 62, 194–55.

26 So far as I know, no *Black Square* copy or version by Golding has been found. I can personally vouch for the rumours, however.

27 Golding, *Visions of the Modern, op.cit.*, p.9.

28 Golding, *Paths to the Absolute, op.cit.*, pp.120, 160.

29 Golding, *Paths to the Absolute, op.cit.*, p.120.

30 If in conversation, Golding never concealed his dislike of writing that put theory first, he resisted the temptation to use his *New York Review of Books* pieces to attack it. He almost exclusively chose to write about books or exhibitions whose focus was on artists and their work, not on how to think about them, and his reviews are almost entirely constructive, even where they feature criticisms. There is an echo here of his seminar teaching style at the Courtauld, as I remember it. He is intent on building on what others discover and say. The exceptions in his reviewing are where shallow opportunism replaces considered argument.

An example is his ruthless demolition of Arianna Stassinopolous Huffington's *Picasso: Creator and Destroyer*. See John Golding, 'The Triumph of Picasso', *New York Review of Books*, vol.35, no.12, 21 July 1988, pp.19–25; Huffington, *Picasso: Creator and Destroyer*, Simon & Schuster, New York, 1988.

31 He is especially acute on colour in his own work in 'From Mexico to Venice – A Dialogue between Richard Wollheim and John Golding', in *John Golding*, exhibition catalogue, Yale Center for British Art, New Haven, 1989, pp.4–22.

32 Wollheim and Golding, *ibid.*, p.14.

33 He finds 'space through light' in Giotto, 'in much Venetian sixteenth-century art', in 'much of Velázquez', in Claude, and 'Turner was one of its greatest exponents', while 'space and light [...] were welded together into the metaphysics' of Braque's 'late studio paintings'. John Golding, 'Frank Stella's Working Space', *Visions of the Modern*, op.cit., pp.332–33.

34 Yve-Alain Bois, 'The Iconoclast', in Bois, Joop Joosten, Angelica Zander Rudenstein and Hans Janssen, *Piet Mondrian*, exhibition catalogue, Haags Gemeentemuseum, The Hague, National Gallery of Art, Washington, DC and Museum of Modern Art, New York, 1995–96, pp.313–72.

35 Golding, *Visions of the Modern*, op.cit., p.44. See John Golding, 'Mysteries of Mondrian', *New York Review of Books*, vol.42, no.12, 22 June 1995, pp.62–63. Another instance is the way Golding writes about Matisse's space. Writing about the exhibition catalogue by Jean Sutherland Boggs, *Picasso and Things: The Still Lifes of Picasso*, Cleveland Museum, Cleveland, 1992, he brings out Matisse's 'recognition' that 'pattern could be used spatially' rather than as a flattening device in Matisse's still-lives. John Golding, 'Live Menu', *New York Review of Books*, vol.40, nos.1, 2, 14 January 1993, p.11.

36 Golding, *Paths to the Absolute*, op.cit., pp.13–14.

37 Golding, *Paths to the Absolute*, op.cit., p.182.

38 Wollheim and Golding, op.cit., p.5.

39 Golding, *Visions of the Modern*, op.cit., p.332.

40 Golding, *Paths to the Absolute*, op.cit., p.137.

41 Wollheim and Golding, op.cit., p.6.

Works on Paper

Two Nudes, 1956

Ink on paper

50.5 × 35.5 cm

Arts Council Collection, Southbank Centre, London

Resting Nude, c.1956

Ink on paper

23.5 x 32 cm

Yale Center for British Art, Gift of the John Golding Artistic Trust

Study for Two Nudes, 1956
Ink on paper
58 × 44 cm
John Golding Artistic Trust

Orvieto, 1958

Ink on paper

52 × 39 cm

Yale Center for British Art, Gift of the John Golding Artistic Trust

Figure Study, c.1961
Charcoal on paper
35 × 26 cm
Yale Center for British Art, Gift of the John Golding Artistic Trust

Untitled, 1964
Gouache on paper
35 × 26 cm
Yale Center for British Art, Gift of the John Golding Artistic Trust

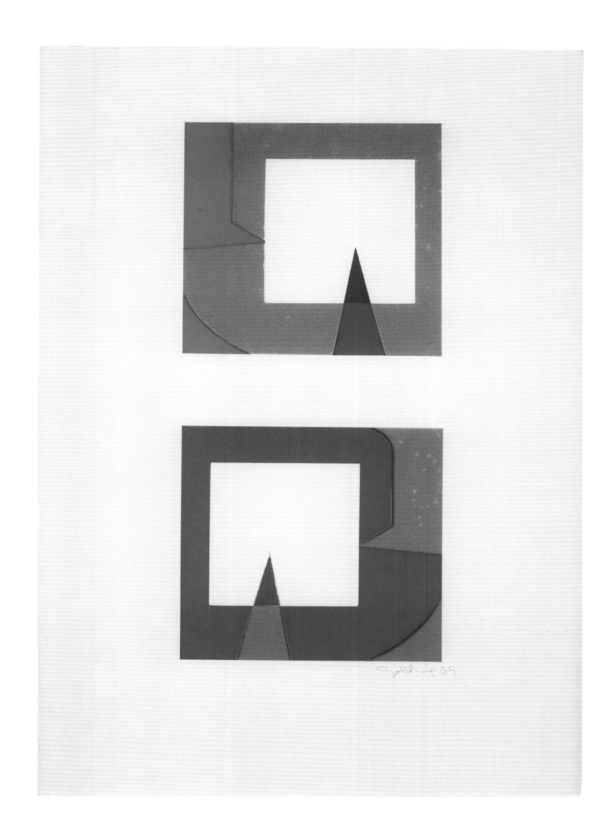

Untitled, 1969
Collage and gouache on card
53 × 37 cm
John Golding Artistic Trust

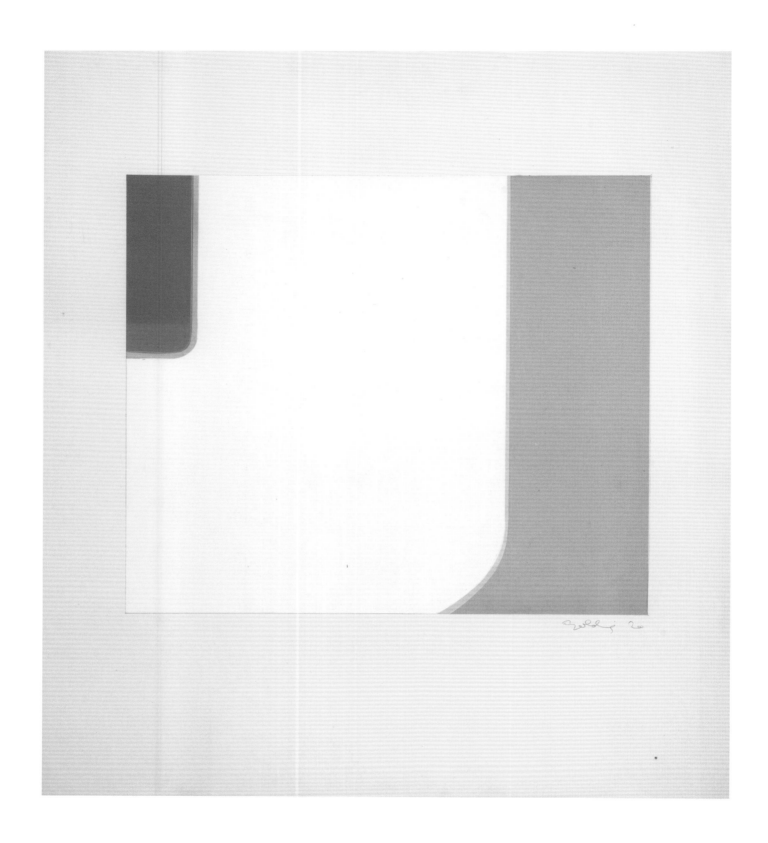

Untitled, 1970
Collage and gouache on card
61 × 54 cm
Yale Center for British Art, Gift of the John Golding Artistic Trust

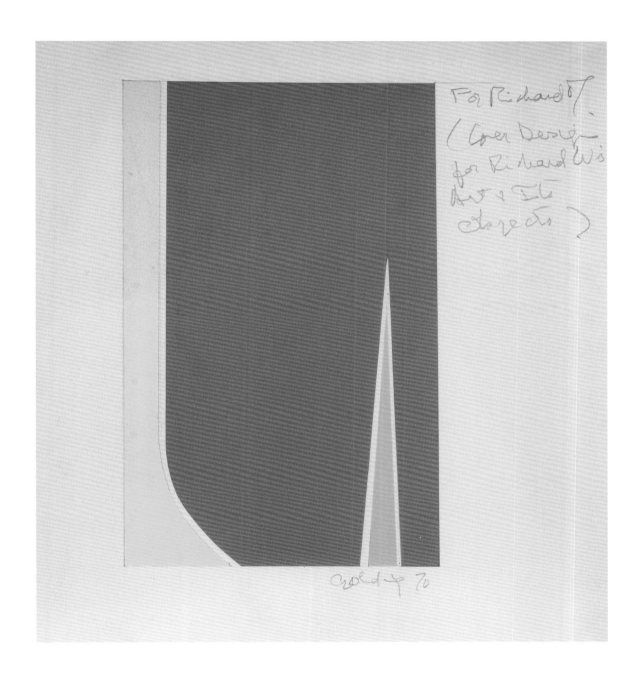

Cover for 'Art and its Objects' by Richard Wollheim, 1970

Collage and gouache on card

25 × 24 cm

Private Collection

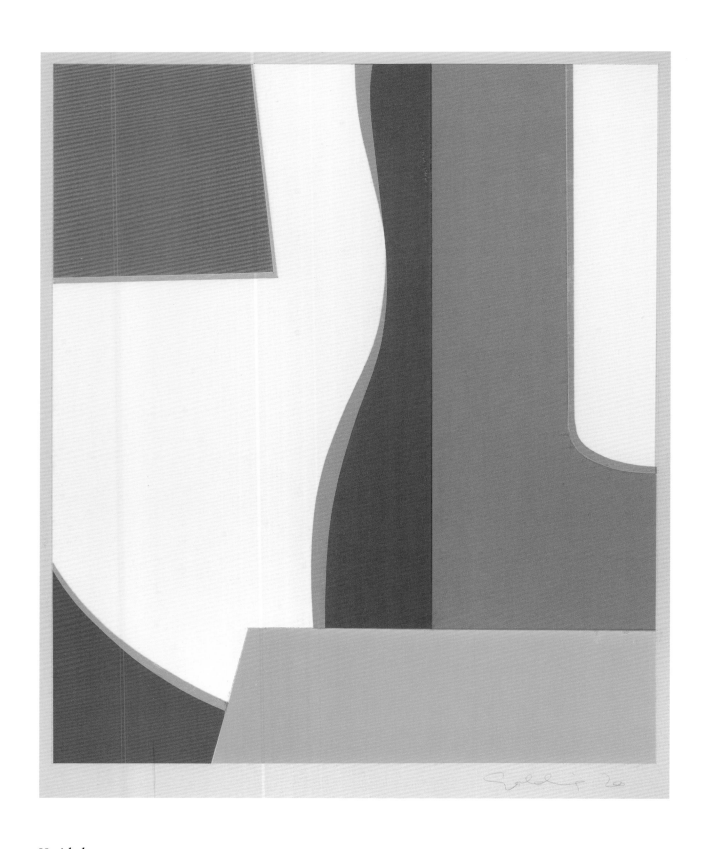

Untitled, 1970
Collage and gouache on card
53 × 38 cm
Yale Center for British Art, Gift of the John Golding Artistic Trust

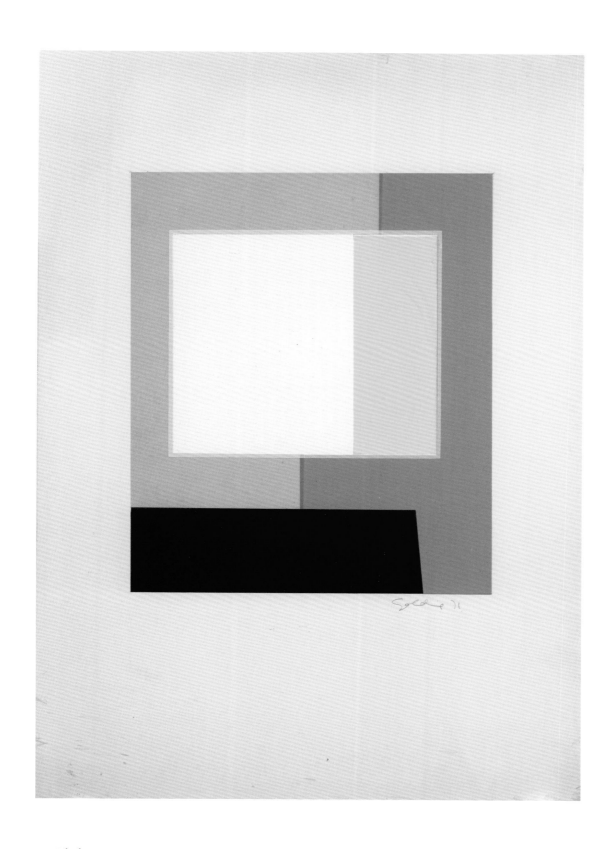

Untitled, 1971

Collage and gouache on card

54 × 38 cm

Yale Center for British Art, Gift of the John Golding Artistic Trust

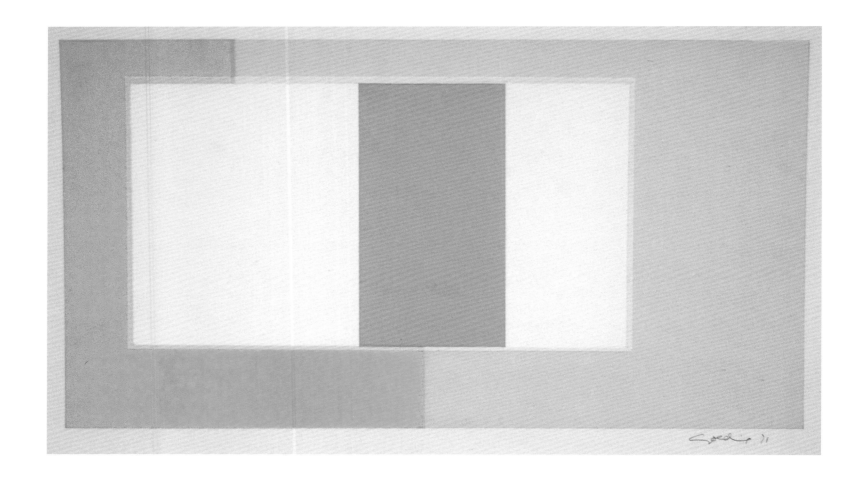

Untitled, 1971
Collage and gouache on card
26.6 × 49.1 cm
Private Collection

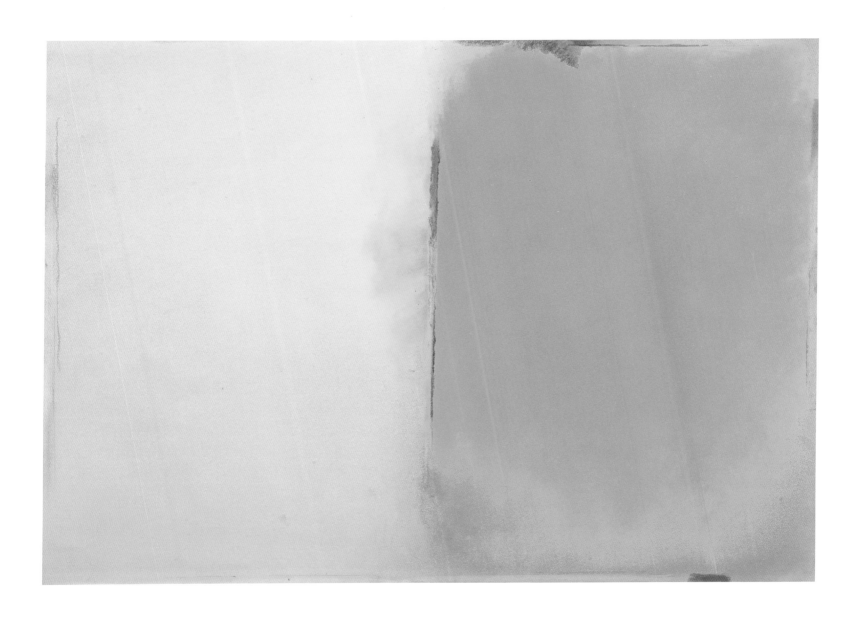

Untitled, 1973
Pastel and mixed media on paper
55 × 75 cm
Yale Center for British Art, Gift of the John Golding Artistic Trust

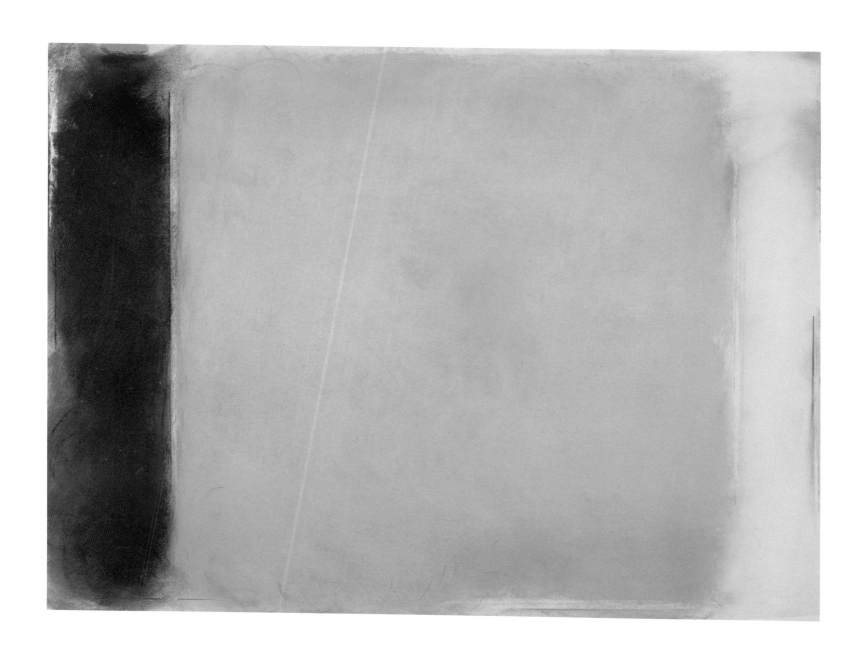

Untitled, c.1973

Pastel and mixed media on paper

59 × 78 cm

Yale Center for British Art, Gift of the John Golding Artistic Trust

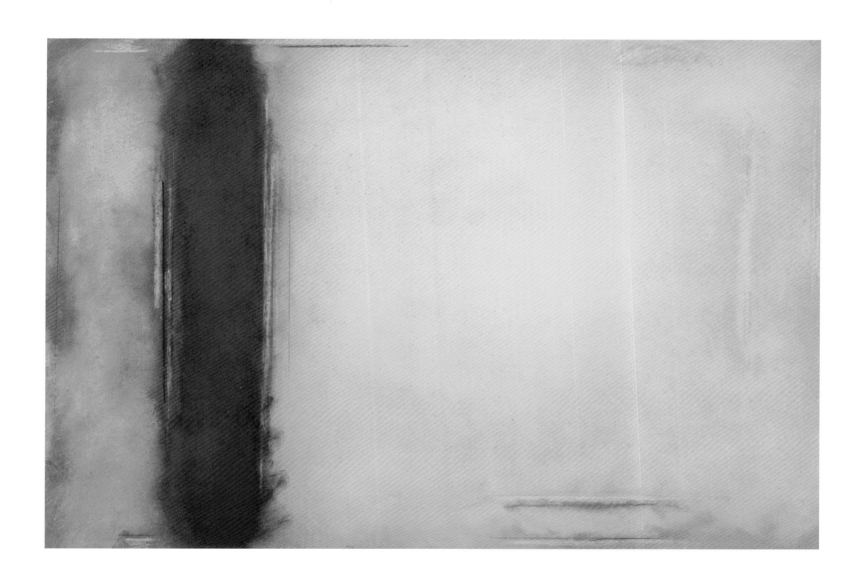

Untitled, c.1975
Pastel and mixed media on paper
55 × 75 cm
John Golding Artistic Trust

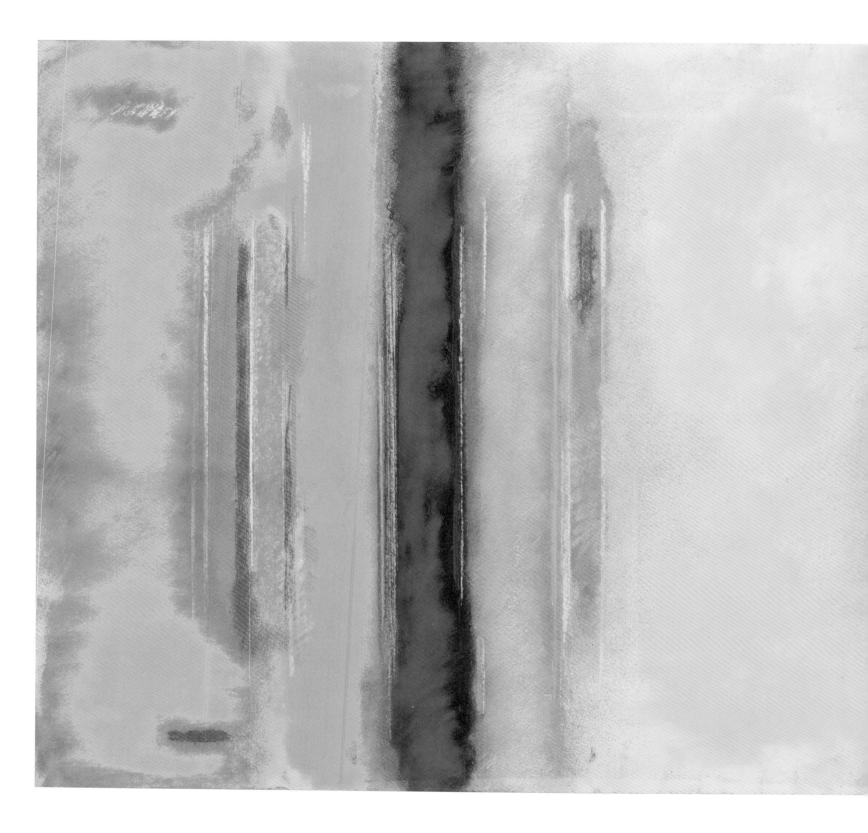

Untitled, 1976
Pastel and mixed media on paper
78 × 134 cm
Private Collection

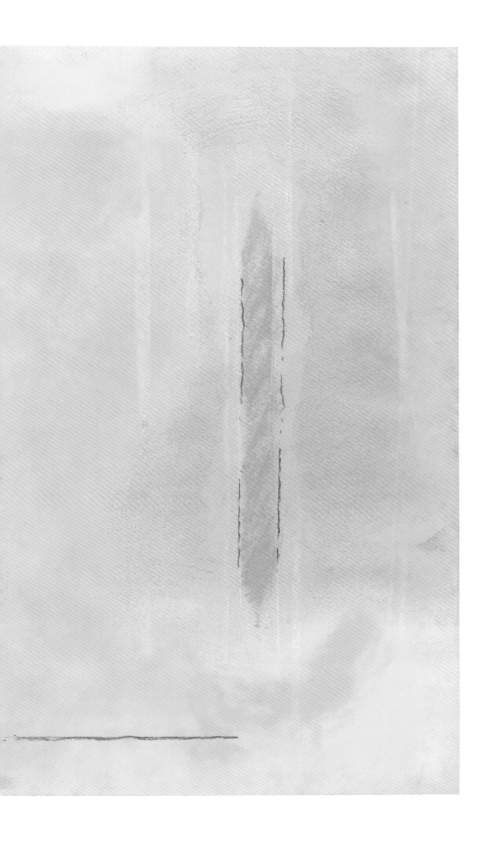

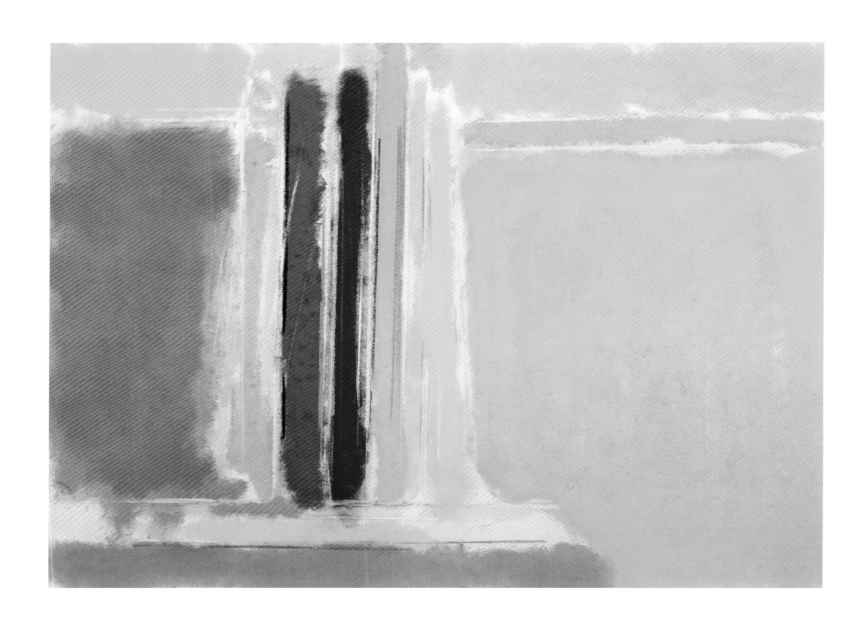

Untitled, c.1979
Pastel and mixed media on paper
55 × 75 cm
Yale Center for British Art, Gift of the John Golding Artistic Trust

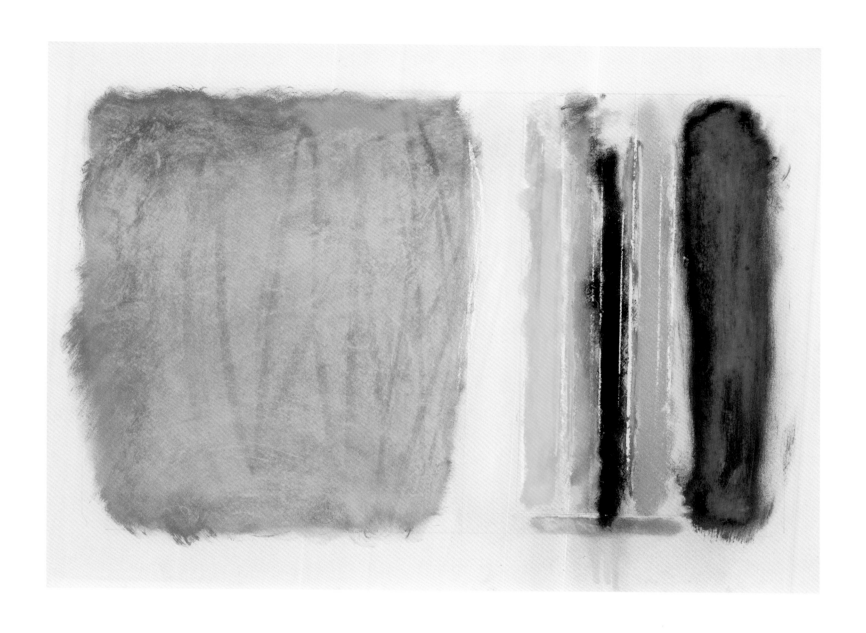

Untitled, 1980–82
Pastel and mixed media on paper
55 × 75 cm
John Golding Artistic Trust

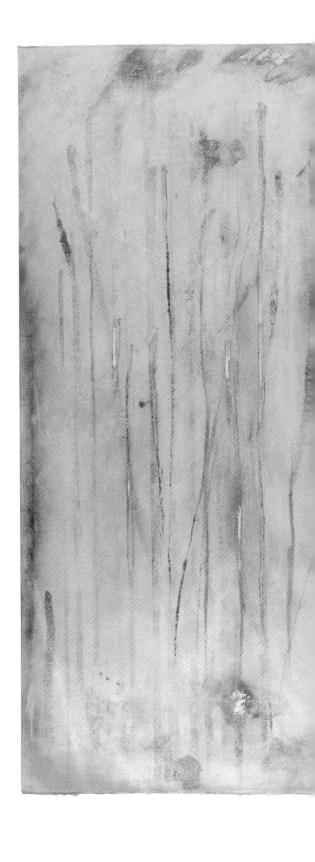

WP 11/81, 1981–82
Pastel and mixed media on paper
101.6 × 152.4 cm
Private Collection

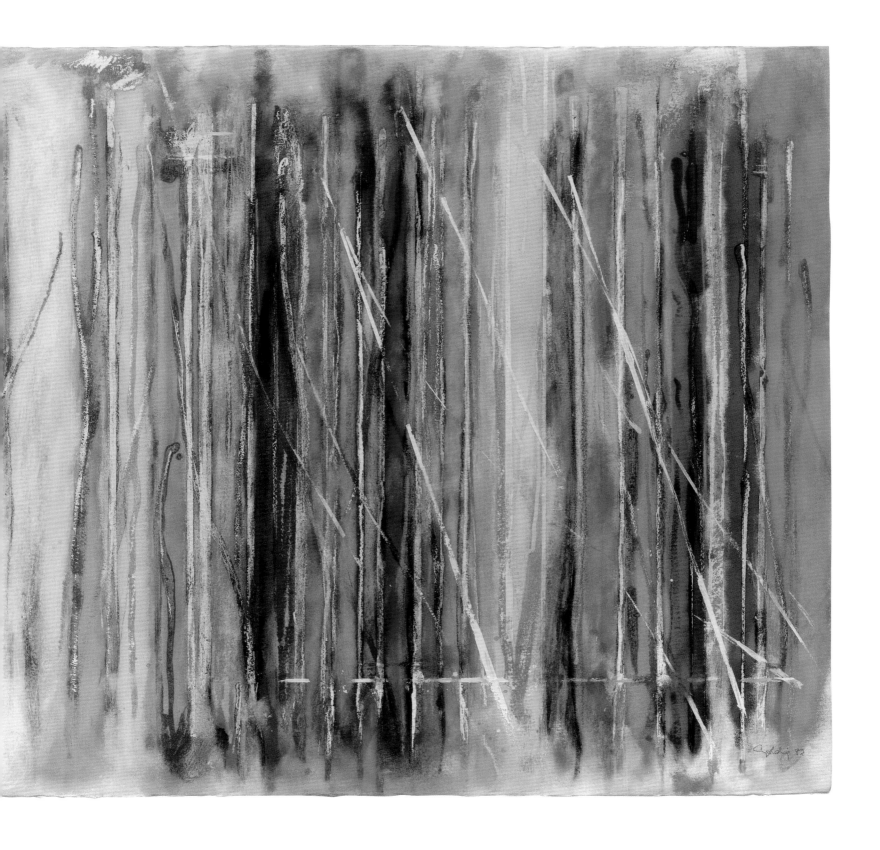

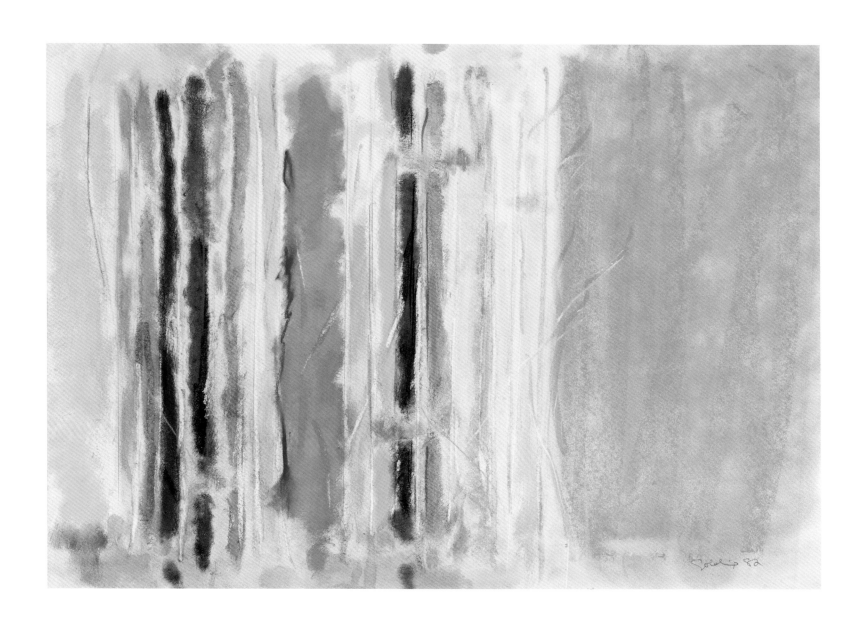

Untitled, 1982
Pastel and mixed media on paper
55 × 75 cm
Yale Center for British Art, Gift of the John Golding Artistic Trust

Drawing 82/2, 1982
Pastel and mixed media on paper
101.6 × 152.4 cm
Private Collection

Drawing 85/5, 1985
Pastel and mixed media on paper
55 × 75 cm
John Golding Artistic Trust

Untitled, 1986
Pastel and mixed media on paper
35.5 × 51.25 cm
Private Collection

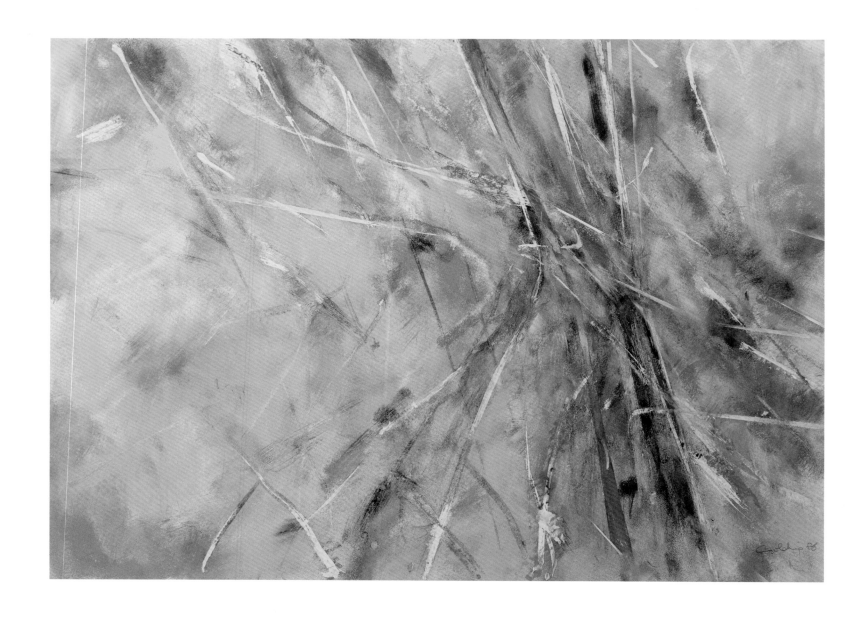

Untitled, 1986
Pastel and mixed media on paper
56 × 75 cm
John Golding Artistic Trust

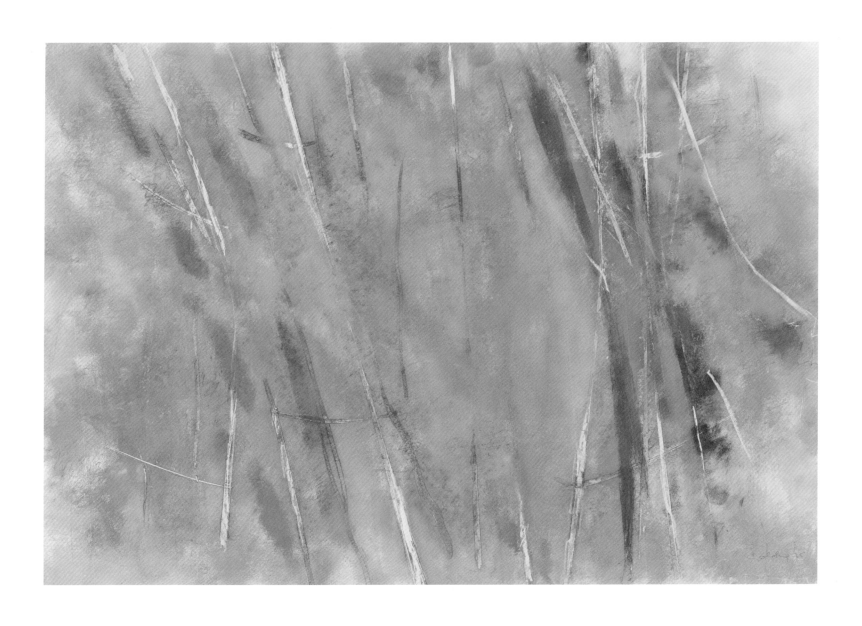

Untitled, 1986
Pastel and mixed media on paper
55 × 75 cm
John Golding Artistic Trust

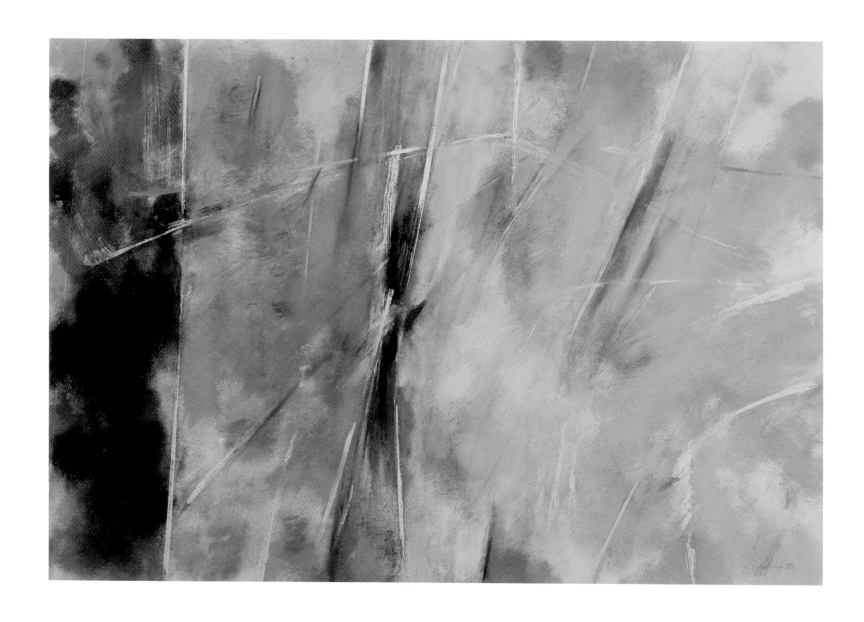

Untitled, 1986
Pastel and mixed media on paper
55 × 75 cm
John Golding Artistic Trust

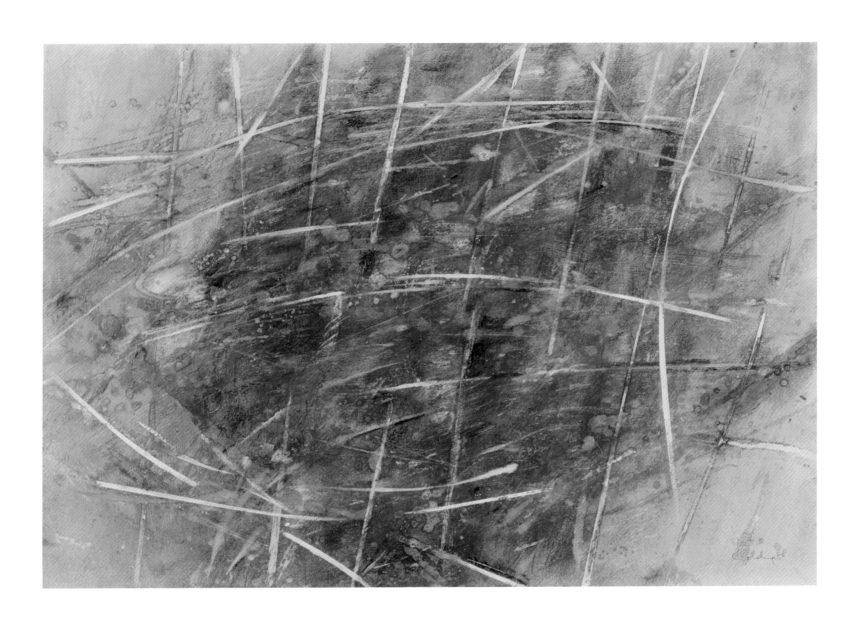

Untitled, 1986
Pastel and mixed media on paper
55 × 75 cm
John Golding Artistic Trust

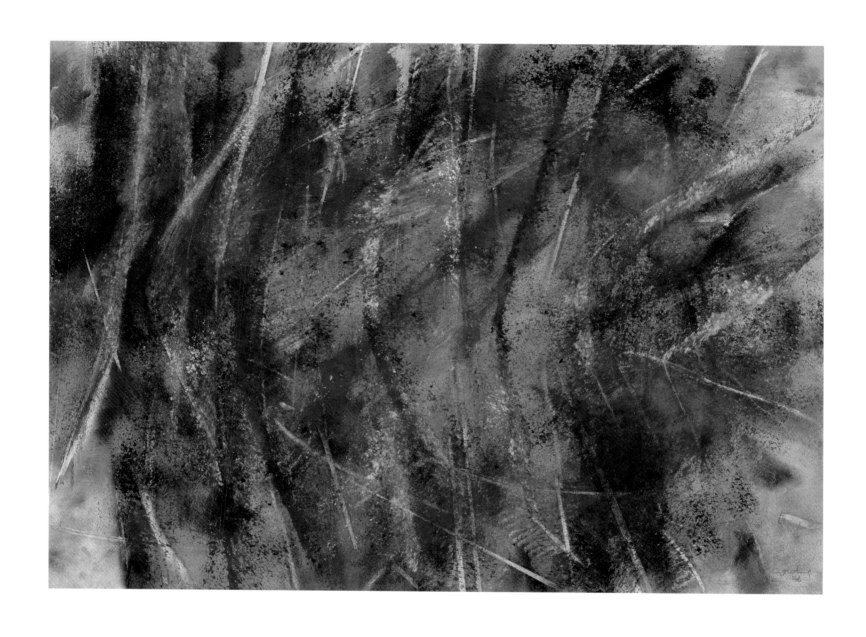

Untitled, 1986

Pastel and mixed media on paper

55 × 75 cm

Yale Center for British Art, Gift of the John Golding Artistic Trust

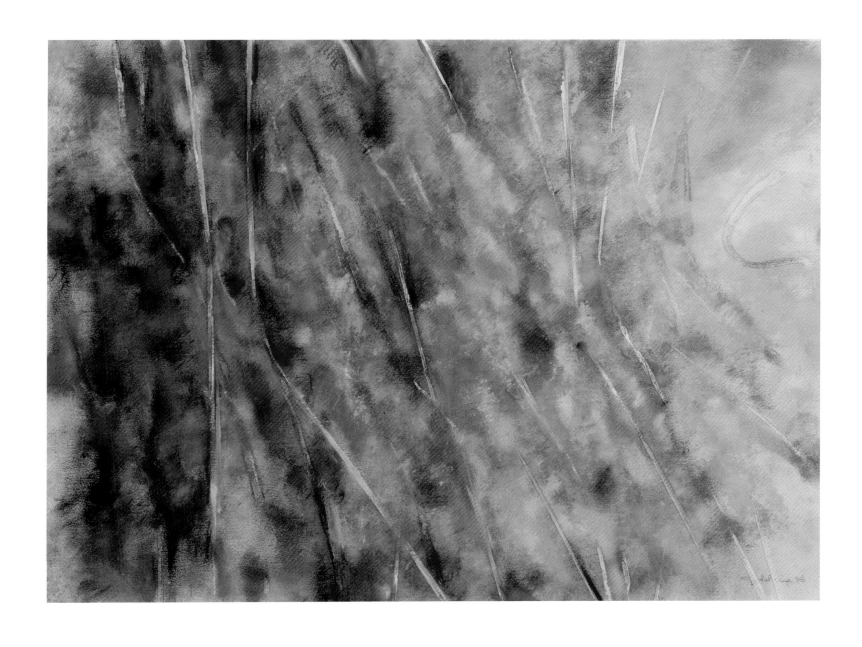

Untitled, 1986

Pastel and mixed media on paper

58 × 76 cm

Yale Center for British Art, Gift of the John Golding Artistic Trust

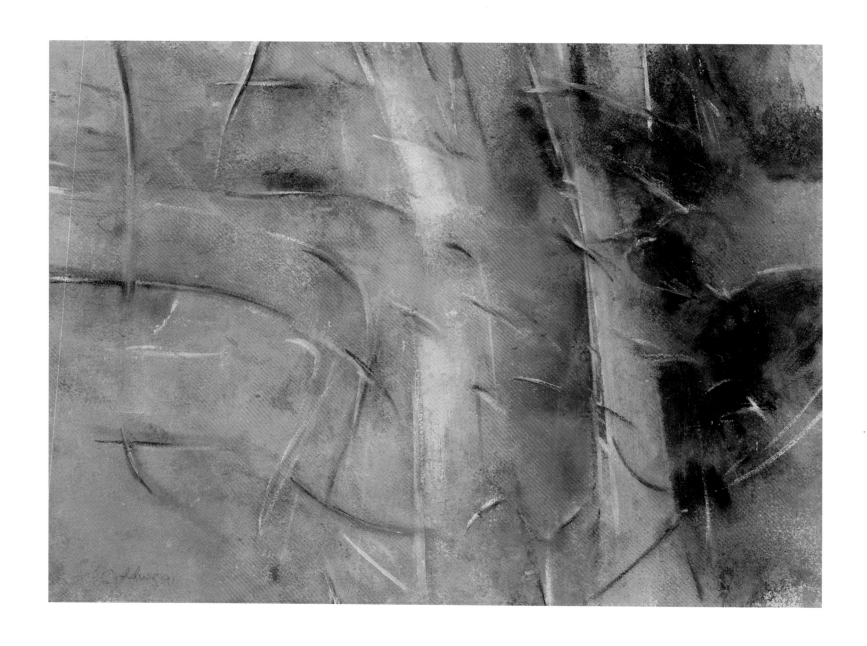

Untitled, 1991
Pastel and mixed media on paper
57 × 76 cm
Yale Center for British Art, Gift of the John Golding Artistic Trust

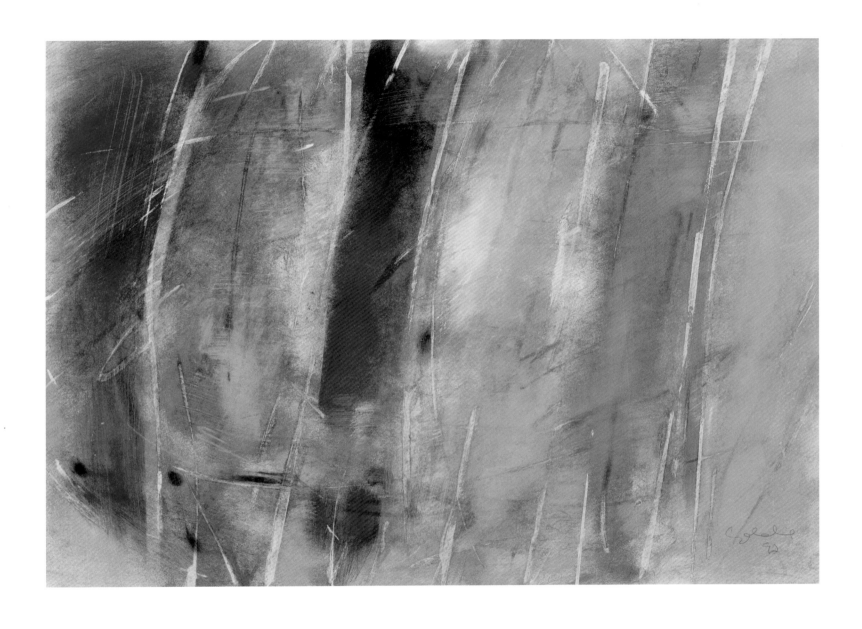

Untitled, 1992
Pastel and mixed media on paper
55 × 75 cm
John Golding Artistic Trust

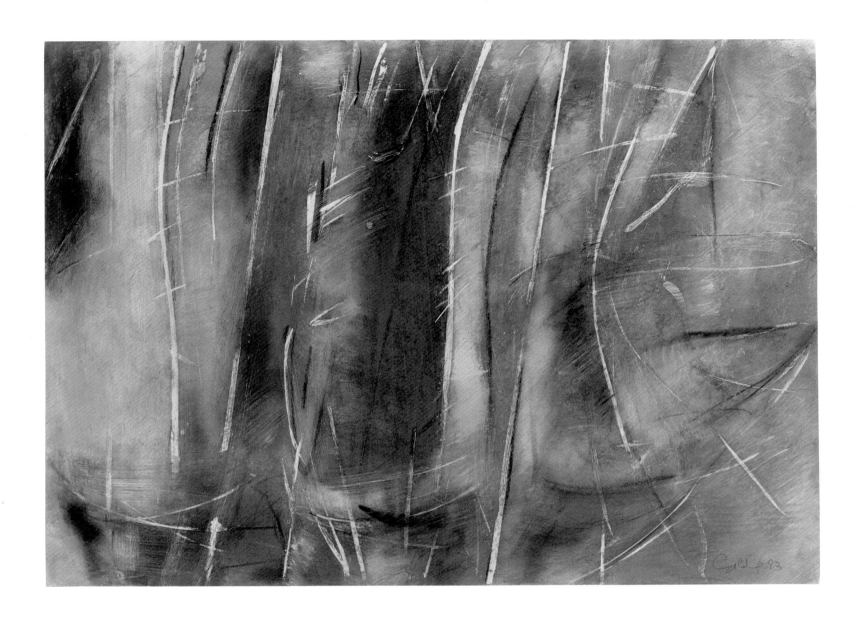

Untitled, 1993
Pastel and mixed media on paper
55 × 75 cm
John Golding Artistic Trust

Installations

Whitworth Art Gallery, Manchester, 1962

238

Nigel Greenwood Gallery, London, 1970

Museum of Modern Art, Oxford, 1971

B IV, 1971
Acrylic on canvas
213 × 365 cm
Tate

242

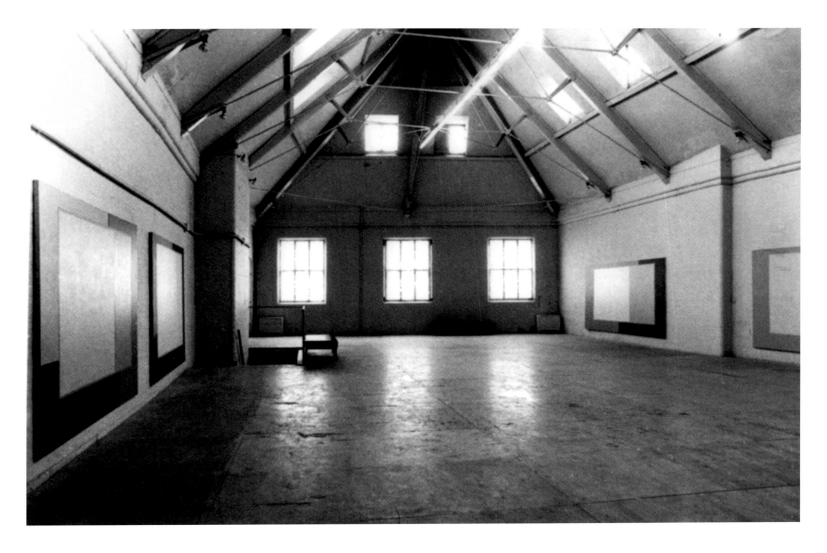

Exhibition leaflet

9 October – 6 November 1971

John Golding

MUSEUM OF MODERN ART
Pembroke Street
OXFORD
Tel. 44553

John Golding was born in England in 1929, but was educated
in Mexico and Canada. In 1951 he returned to Europe to do
post-graduate work at the Courtauld Institute of Art, London
University. He obtained a Ph.D. in 1957 and at the same time
began painting seriously. His book 'Cubism 1907–14' was

Tues – Sat 10–5
Wed 10–7.30
Sun 2–5
Mon Closed

published in London and New York in 1959. French and Italian
editions followed in 1962 and a revised English edition appeared
in 1968. In 1970 he organized (together with Christopher Green)
the 'Leger and Purist Paris' exhibition at the Tate Gallery.
He is at present on the staff of the Courtauld Institute, and

Works may be purchased

lives and works in London.

Exhibitions

1962 Gallery One (one-man exhibition)
1962 'Three Aspects of Contemporary Art'
 (with Elizabeth Frink and Trevor Bell)
 Whitworth Museum – Manchester
1964 Bear Lane Gallery – Oxford
1966 Axiom Gallery (joint exhibition with Charles Perry)
1970 Nigel Greenwood Gallery (one-man exhibition)

Collections

Arts Council of Great Britain
Victoria and Albert Museum
Southampton Municipal Gallery
Whitworth Art Gallery – Manchester
Private Collections in England and America

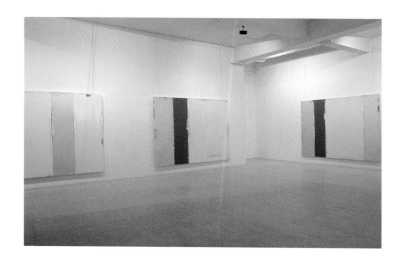

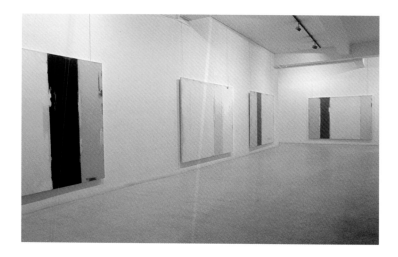

Rowan Gallery, London, 1975

D (S. K.) VIII, 1975
Acrylic on canvas
165.1 × 228.6 cm
British Council Collection

New Art Centre, Roche Court, 2003

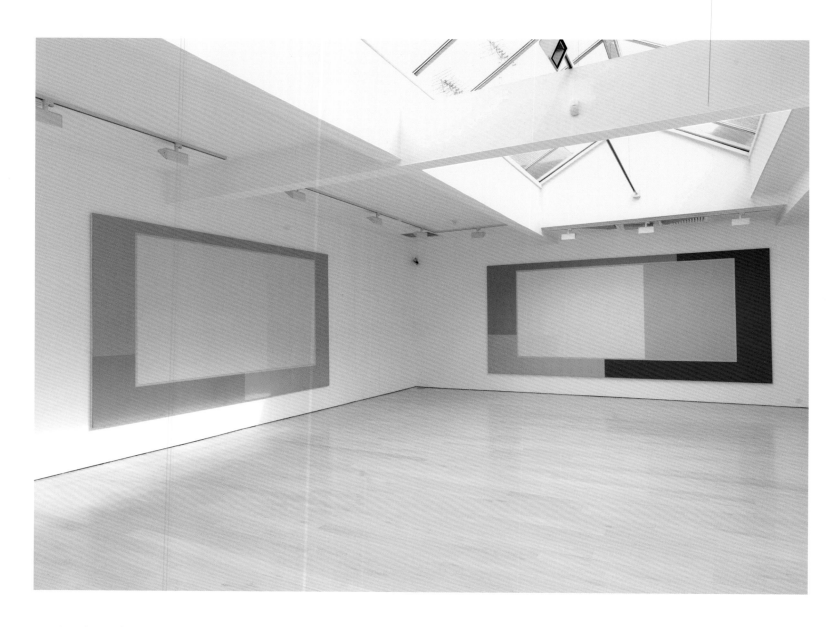

Annely Juda, London, 2012

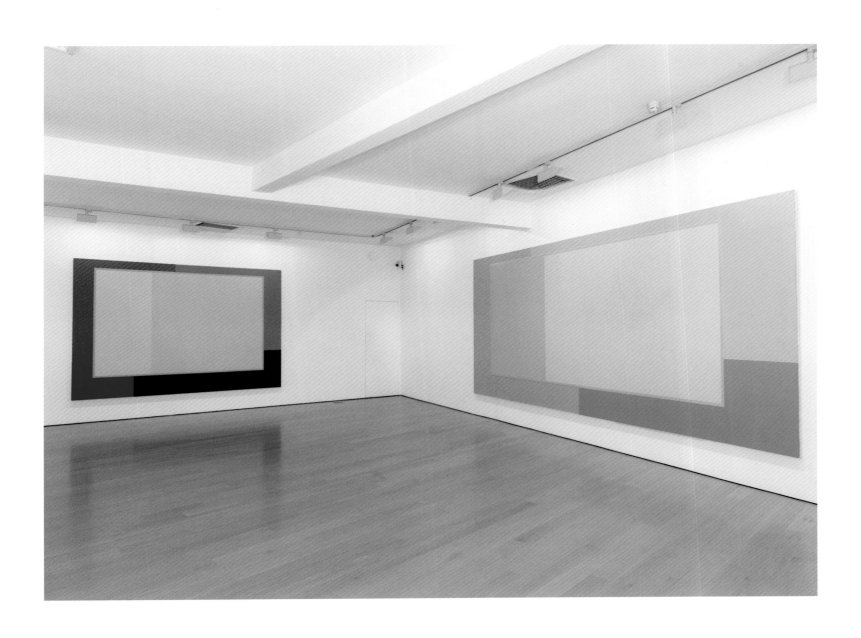

Early 1960s

Biography

John Golding (1929–2012) was born in Hastings, East Sussex, but brought up from early childhood in Mexico, where his mother's family had settled in the mid-nineteenth century. As a young adult, he met Leonora Carrington, the expatriate Surrealist who had made her home in Mexico during the Second World War. Through Carrington he got to know filmmaker Luis Buñuel and the poet Octavio Paz, as well as the Mexican muralists Juan O'Gorman and Diego Rivera, whom he exhibited alongside in Peru in 1961. But of this eclectic circle it was the work of José Clemente Orozco that resonated most deeply with Golding, who he would continue to refer to as his greatest source of inspiration throughout the rest of his life.

As an undergraduate student at the University of Toronto, Golding made regular trips to New York, familiarising himself with its abundance of museum art collections, and above all with the displays of European modernism in the Museum of Modern Art. He went on to pursue postgraduate studies at the Courtauld Institute of Art in London between 1951 and 1957, with a break

Early 1950s

Late 1950s

between 1953–54 when he returned to Mexico City to lecture and paint in the art department of the American University. In 1953 he saw a major show of Cubism in Paris and decided to write his doctoral thesis on the early years of the movement, which formed the basis of his seminal book on the subject. Golding was dedicated to his work as an artist, but the acclaim for this initial book made him a pioneer of modern art history and drew him into academic life. He taught at the Courtauld Institute until 1981, when the Royal College of Art offered him the position of Senior Tutor in the Painting School. He was Slade Professor of Fine Art at Cambridge in the 1976–77 academic year; and between 1984 and 1991 he was a trustee of the Tate Gallery.

Although this art-historical background was very important to him, Golding considered himself primarily a painter and kept a studio, first at the Stockwell Depot in Brixton, and later at his home in Hammersmith. He exhibited in Mexico City in 1958 and 1961, but the first exhibition of his paintings in the UK took place at the Whitworth Art Gallery in Manchester in 1962 (pp.238–39). Golding's early paintings are dark and visceral, his human and animal subjects often splayed or tortured. He began making totally abstract works in the mid-1960s, in a development that echoed the move from figuration to abstraction in the works of the early abstract artists that he analysed so incisively in his writing. In 1974 he joined the Rowan Gallery (p.244), which was run by Alex Gregory-Hood, a great champion of Golding's work.

The intellectual clue that most clearly indicates his practice as a painter lies in his *Paths to the Absolute* (2000). The book was essentially a transcript of his

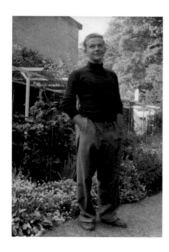

Early 1950s in Mexico City Mid-1970s

AW Mellon Lectures of 1997. It is in *Paths to the Absolute* that Golding makes his strongest case for abstract painting, arguing that 'at its best and most profound, abstract painting is heavily imbued with meaning, with content, and that, in order to make this content palpable, new formal pictorial innovations must be found to express it'.

In a career that spanned almost sixty years, Golding was the subject of a series of one-man exhibitions at major galleries, including Nigel Greenwood, London (pp.240–41), Kettle's Yard, Cambridge and Annely Juda, London (pp.246–47), as well as galleries in Tokyo and Sydney, and the Yale Center for British Art, New Haven. His work was additionally shown alongside Bridget Riley, John Hoyland, Frank Auerbach, Peter Blake, David Hockney and Richard Hamilton in important group exhibitions such as *British Painting '74* at the Hayward Gallery, and *British Painting 1952–77* at the Royal Academy of Arts, both London. Golding was awarded a CBE in 1992, and elected a Fellow of the British Academy in 1994.

1998

Public Collections

Albright-Knox Art Gallery, Buffalo

Art Gallery of Hamilton, Ontario

Art Gallery of New South Wales, Sydney

Arts Council of Great Britain

British Academy

British Council

The Fitzwilliam Museum, Cambridge

Hunterian Art Gallery, Glasgow

Kettle's Yard, Cambridge

London Borough of Camden

Museum of Modern Art, New York

National Gallery of Australia, Canberra

National Galleries of Scotland, Edinburgh

Southampton City Council

St Antony's College, University of Oxford

Tate

University of Hull Art Collection, Hull

Victoria and Albert Museum, London

Whitworth Art Gallery, Manchester

Yale Center for British Art, New Haven

York Museums Trust

Published by **Ridinghouse** in 2017

46 Lexington Street
London W1F 0LP
United Kingdom
ridinghouse.co.uk

Distributed in the UK and Europe by
Cornerhouse Publications
c/o Home
2 Tony Wilson Place
Manchester M15 4FN
United Kingdom
cornerhousepublications.org

Distributed in the US by
RAM Publications + Distribution, Inc.
2525 Michigan Avenue Building A2
Santa Monica, CA 90404
United States
rampub.com

For the book in this form © 2017 Ridinghouse

Edited by Jenna Lundin Aral
Copyedited by Dorothy Feaver
Designed by Tim Harvey
Set in Albertina
Printed in Italy by Opero srl

ISBN 978-1-909932-38-8

British Library Cataloguing-in-Publication Data: A full
catalogue record of this book is available from the British
Library

The publication of this book coincides with a major gift of
works from the John Golding Artistic Trust to the Yale
Center for British Art.

Ridinghouse